aboriginality

CONTEMPORARY ABORIGINAL PAINTINGS & PRINTS

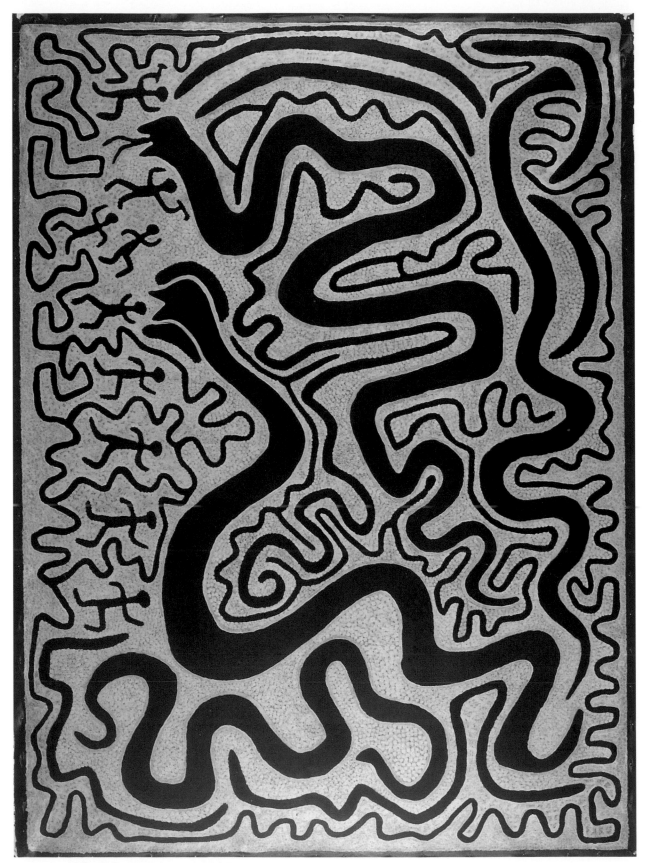

Jimmy Pike *Kalpurturlu Yagangarni. A Real Story* 1988 acrylic on canvas 165.2 × 119.7 cm

aboriginality

CONTEMPORARY ABORIGINAL PAINTINGS & PRINTS

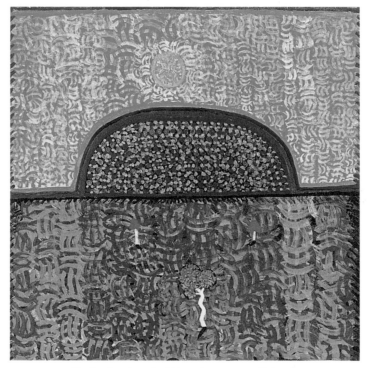

Trevor Nickolls **Centre Landscape** 1988 acrylic on canvas 91 × 121.5 cm

JENNIFER ISAACS

University of Queensland Press

Concept and design by Susan Kinealy
Principal photographer: Per Ericson
Project co-ordination: Meredith Aveling and Laura McLeod
Supervising editor: Sue Abbey

First published 1989 by University of Queensland Press, Box 42, St Lucia,
Queensland, 4067 Australia

Typeset by Savage Type Pty Ltd, Brisbane
Printed in Australia by William Brooks Queensland

Distributed in the USA and Canada by
International Specialized Book Services, Inc.,
5602 N.E. Hassalo Street, Portland, Oregon 97213–3640

Cataloguing in Publication Data

National Library of Australia

Isaacs, Jennifer.
Aboriginality: contemporary Aboriginal paintings
and prints.

ISBN 0 7022 2220 8

[I]. Art, Australian — Aboriginal artists. 2. Art,
Australian (Aboriginal). [3]. Aborigines, Australian
— Art. I. Title.

760'.0994

contents

ACKNOWLEDGMENTS

I wish to thank the many artists, galleries and friends who allowed their works to be photographed and included in this book. Others helped with logistics and enthusiasm. Particularly Anna Eglitis, Chris Watson, Ace Bourke, Gabriella Roy, Anthony Wallis, Marlene Hall. I am particularly grateful to the Roslyn Oxley Gallery, Sydney and Boomalli Aboriginal Artists Ko-operative, Sydney. Chris Keeler of the Victorian Aboriginal Cultural Heritage Trust provided photographs of the Leslie Griggs paintings, and Desert Designs, Fremantle, assisted with transparencies of Jimmy Pike's paintings. Thanks to the Aboriginal Artists Gallery, Sydney and Cooee Aboriginal Art for permission to photograph works exhibited. I would also like to thank the Regional Galleries Association for arranging for the photography of the cover work by Sally Morgan reproduced by courtesy of the Sir William Dobell Art Foundation. I am grateful to the Williamstown Summer Festival Ltd for providing the transparency of "A Bay Up Home" by Ellen José, and to Ros Premont and Mark Lennard for interviewing Barney Daniels Tjungurrayi, and providing biographical details.

Curators of exhibitions which have focused on urban contemporary Aboriginal art have paved the way for this publication. These include Chris Watson and Jeffrey Samuels ("Koori Art '84, '85"), Ace Bourke ("Art & Aboriginality" 1987/88) and Ruth and Vincent Megaw ("The Cutting Edge" 1988). I must also pay tribute to the guidance and foresight of Ulli Beier whose book on Trevor Nickolls and profile on Raymond Meeks published in *Long Water* were the basis for my text on those artists.

Photographic Credits

All photographs of paintings and prints were taken by Per Ericson except for the following:
Robert Campbell Jnr — courtesy Roslyn Oxley Gallery; Banduk Marika — Michael Courtney; Lin Onus — courtesy Artist; Fiona Foley — courtesy Roslyn Oxley Gallery; Barney Daniels Tjungurrayi — Mark Lennard; Wanjidari — courtesy Upstairs Gallery, Cairns; Jimmy Pike — courtesy Desert Designs; Heather Walker and Jennuarie — courtesy John Walker; Mabel Edmund, AM — John Emmet; Trevor Nickolls — courtesy Marlene Hall; Sally Morgan — Victor France; Mundabaree, Zane Saunders and Joseph McIvor — John Emmet.

Portraits of the artists were provided by the artists. I am grateful to Elaine Kitchener for the photographs of Raymond Meeks, Jeffrey Samuels and Jenuarrie; to Ellen José for the photograph of Trevor Nickolls; C. Moore Hardy for the photograph of Pamela Johnston and Claude Coirault for Barney Daniels.

As always, my mother, Carmel Pepperell, has been very supportive and assisted with typing the manuscript. Lastly, and most importantly, I must thank Susan Kinealy, without whose talent and personal commitment this project could not have happened.

foreword

Aboriginal art is both age old and contemporary — contemporary in that it is here and now. For many white people, however, Aboriginal art means only ancient cave paintings. The very contemporariness of contemporary Aboriginal art poses a problem for such audiences. What doesn't fit their neat stereotype of Aboriginal art raises questions concerning its Aboriginality. Such a misconception presupposes that Aboriginal people and their art remain frozen in time. It must be recognised that Aboriginal culture will change, Aboriginal artists will change. They have changed.

The cross-culturalism of today's Aboriginal artists is expressed in a mix of traditional images and material. It is non-classical, non-tribal and most often politically motivated. Hypocritically this political nature is difficult for some outside audiences to accept. Picasso's *Guernica*, arguably (in European eyes) one of the greatest paintings of the twentieth century, is essentially a political statement. However, worldwide interest in contemporary Aboriginal art is building such that it is now a recognised and accepted artform.

There is something else that runs through all Aboriginal art, something other Australian artwork lacks. It is the common thread of Aboriginal spirituality.

JOHN MUNDINE
Art Advisor of Ramingining
and Curator of Aboriginal
Art at the Art Gallery
of New South Wales

introduction

Only a few decades ago the term "contemporary Aboriginal paintings" might have meant the watercolours of the Aranda School in Central Australia. Now modern expressions of an artist's Aboriginality are greatly diverse in content, media and approach, reflecting the difference in backgrounds and the experience of the artists. The paintings and prints in this volume speak of this diversity but offer mostly a statement about the unity of Aboriginal people, the defiant continuity of their cultural traditions and the personal search of many individual artists for their own Aboriginal identity.

A vibrant, colourful, expressive contemporary Aboriginal art movement has developed which not only reflects traditional themes and images, but often tackles social issues and expresses the feelings and dilemmas of modern indigenous peoples.

"Traditional" painting itself has undergone great changes. The Central Desert acrylic paintings that emerged after 1971 have had a significant effect on public perceptions of the "modernity" of Aboriginal art. These utilise new media — canvas, acrylic paints and sometimes artists' boards. Individual artists from this group, particularly from the founding company at Papunya, are also engaged in major public art commissions including murals, installations, the mosaic at the new Parliament House and even surface designs on modern furniture. Although these remain religious-based expressions of "country" and Dreaming, they are, nevertheless, political also, as they can be seen as statements of the artists' integral relationship to land, in a sense "title deeds".

The Fourth World has been used by some as a collective term to describe indigenous peoples whose lands fall within the national boundaries and under the governments of the countries of the first, second and third world. They have no "country" of their own and are in such a minority that they have little power to direct their "collective lives".

All Aboriginal people are in such a situation. Their power to direct attitudes and reoccupy and re-control their country and thus their collective lives largely depends on their power to influence — and in this art plays a major role, particularly for dispossessed Aborigines of the eastern and southern states: Murris of Queensland, Koories of New South Wales and Victoria, Nungas of South Australia and Nyoongahs of Western Australia. Most

of the artists in this volume come from these communities.

Some urban-based Aboriginal artists work alone like Trevor Nickolls, Lin Onus or Sally Morgan. Others have formed artists' cooperatives. "Boomalli" in Chippendale, Sydney has members from all art forms — Koori photographers, film-makers, sculptors, painters, and printmakers.

Many urban Aboriginal artists are self-taught but most have now received an art school education and have emerged with a technical and conceptual talent which they are turning towards an examination of their own Aboriginality, its religious background and social context in modern Australia.

In Sydney, the cooperative artists' space, Boomalli, has become an inspiration for similar Aboriginal artists' groups elsewhere. Fiona Foley, one of the founding members also cites the pivotal exhibition "Koori Art '84" as a turning point:

During 1984 Koori art was given exhibition space at the "Artspace" Gallery; it was history in the making, titled "Koori Art '84". It was an initial meeting place for Koori artists, and it was not until 1987 that Boomalli Aboriginal Artists Ko-operative became a formalised community of Koori artists.

We all undertook an art education through mainstream art institutions. During that time we came into contact with overt and subtle forms of racism.

Boomalli encourages a diverse range of Koori art and craft, and networking between traditional and east coast Aboriginal people. By exhibiting the work of these artists we are giving them the self-respect and determination to pursue a career in the arts and our culture can only grow stronger.

Most artists paint or print primarily for self-expression, and feel it is paramount that their work be accepted by each other first, within the Aboriginal community. A few have made central roles for themselves in the wider public perception of the strength and culture of modern Aboriginal paintings. Included in this group is Jimmy Pike from Western Australia. To quote one commentator, Jimmy Pike "rides the back of the fashion industry" through his professional association with "Desert Designs" which market his designs for the fashion industry.

Sally Morgan also from Perth and best known for her gifted writing is an unusual addition to the ranks of urban artists. In her autobiographical paintings her brilliantly coloured, simple and childlike figures and images are laid together in complex groups and patterns that reveal a sophisticated spiritual approach. The "first wave" of urban Koori artists with a high profile included Trevor Nickolls, Lin Onus, Jeffrey Samuels, Raymond Meeks, and Fiona Foley. Their ranks have expanded greatly in recent years.

In Cairns, North Queensland, over the last four years, there has been an explosion of Murri art talent. Cairns has always had a large Aboriginal and Islander population. The Aborigine and Torres Strait Islander Associate Diploma of Art course established in 1984, filled a necessary role offering training to Aborigines of all ages in all facets of the arts. Graduates include Wanjidari, Jenuarrie, Heather Walker, Pooaraar. Zane Saunders and Joseph McIvor are currently completing the course.

The work of contemporary Aboriginal artists has immediate impact. The colour, images and strength of the themes are often compelling. Few of the artists retain the traditional ochres as their exclusive palette but choose the most exciting colour range possible. Like contemporary arts movements of modern indigenous peoples of South America, Africa and the Pacific, the changes in ethnic arts reflect the onslaught of industrialisation and tourism, usurpation of land and culture. Yet in all these areas, as in Australia, the very shock of the "tree of life" that such confrontation produces, gives a new creative dynamism to contemporary painting.

Most of the artists represented in this volume, even the tradition-based artists like Jimmy Pike and Banduk Marika express the total influences which have come upon them as contemporary Aboriginal artists.

For some, the journey is intensely personal — a search through art to find the answer to the question "Who am I?" or as one artist asks "What is anyone?" The vision of a place here, the mention of grandfather's totem there, and the adoption of a traditional Aboriginal name sometimes follow. For Sally Morgan, the journey was both intellectual and intuitive. Unaware that she was Aboriginal until she was fifteen, she was stunned to see in the drawings of a tribal relative in the Kimberleys of Western Australia the same technique and imagery she had used in her own art as a child. This encouraged her to continue that style in her modern paintings as a confident expression of her Aboriginality.

Most artists *like* to paint or make prints but a great number also want to express feelings, history, culture, and continuity. Sometimes the feelings expressed are about life on the edge, or are meant to arouse people about social conditions. Leslie Griggs with a certain candour remarked of his paintings, "I find it's the best way to get back at the system without leaving myself open to prosecution".

The italicised quotes have been submitted by each artist as a personal statement about their art.

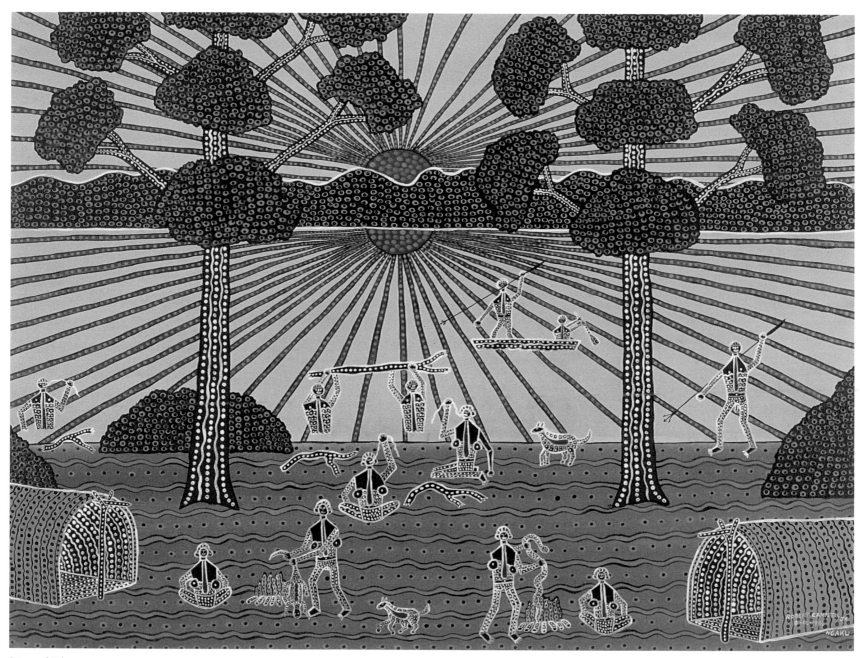

Giver of Life 1987 acrylic on canvas 91 × 120 cm

robert campbell jnr

Robert Campbell is an artist of the Ngaku people of northern New South Wales. He was born in 1944 in Kempsey and spent his early years in an extended family living a settled, but nevertheless, Aboriginal lifestyle which related strongly to the coastal landscape, the mangroves and the Australian bush.

He went to school until the age of fourteen and at primary school first learnt to draw by making images on the boomerangs that his father carved from local wattle and mangrove wood. He enjoyed going on expeditions into the bush for craft materials and "getting good boomerang cuts — beautiful cuts from 'sally' wattle and mangrove."

In the early fifties it was common for coastal Aboriginal communities to make artefacts like boomerangs for pleasure and also to sell, often to tourists at beach resorts.

Robert Campbell was named after his uncle. His father, Thomas W. Campbell, was a famous boomerang-maker who decorated his own carved shapes with poker work. Robert first drew these designs for his father — kangaroos, animals, birds. His father would trace the pencilled lines with red-hot wire to burn in the images. The young boy was not to know that this early experience in art would lead to his success as a mature age artist in the late 1980s.

In Kempsey, as a young man, Robert continued to paint, gathering whatever materials were to hand. His early naive landscape paintings of scenery, gardens and idealised images were on cardboard with gloss paint. He sold these locally — as he says "for a carton".

Campbell hints at times in his life that were far from idyllic — years spent in Sydney working in factories, as a brickie's labourer, pea picking, and other manual labour. "It was all work that was not good enough for white people." He resolved to change things.

After returning to Kempsey he continued to paint but the impetus for the notable new series of works shown at Roslyn Oxley's Paddington Gallery in Sydney in 1987 and 1988 did not come until later. In Kempsey, Campbell met another Sydney artist, Tony Coleing, who gave him paint and suggested he try canvas and artist's board. The new work that developed courageously, confidently and sometimes humorously, tackled all the current

political and social themes that confront Aborigines in Australia. These bright, clear storytelling cartoon-like paintings touch on themes of death, political self-determination, segregation at local picture theatres, colonial conquest and such mundane experiences as suburban living and working on the railways. There is a great deal going on in these paintings. The figures — white, black and brown — wear ties, even young koalas and kangaroos are bedecked with these images of suffocation and conformity.

Robert Campbell's paintings tell of his experiences of racism in small country towns. He has been excluded from bars, roped off at the front of the picture theatre, and suffered grief over the destruction wrought by alcohol in the community.

The artist paints in his open air "studio" in his backyard at Kempsey on a table, in the shade of two trees, often working on two or three canvases or boards at the one time. As the sun moves he packs up and adjusts his "studio" a little to the north or a little to the south, so that he's in the shade again.

Recently Robert has encouraged a new group of Koori artists at Kempsey — The Kempsey Aboriginal Artists — and in late 1988 the group held an exhibition at Boomalli in Sydney. It is clear that Robert Campbell has developed a "following" in style among his own people. It is through art they can express to a far greater degree than once thought possible the strength of their Aboriginality and cultural connections to the land and its history.

When I paint, I don't copy or make a sketch first. It just comes from within me and I just keep going. I have a picture in my mind — it's the spirit in me. It just guides my hand. And that's the result of it.

I've seen some Aboriginal drawings in magazines from the Northern Territory and I kept adding and created my own style — the Aboriginal spirit in me that I'd lost. When we were on the mission the old people were not allowed to talk the lingo — not allowed to teach us, they were too frightened they would be sent away or something. I'm forty-five years old now and yet I'm still searching for that Aboriginal identity that I've lost. I paint about things that touch me personally — whatever has happened to me in my lifetime.

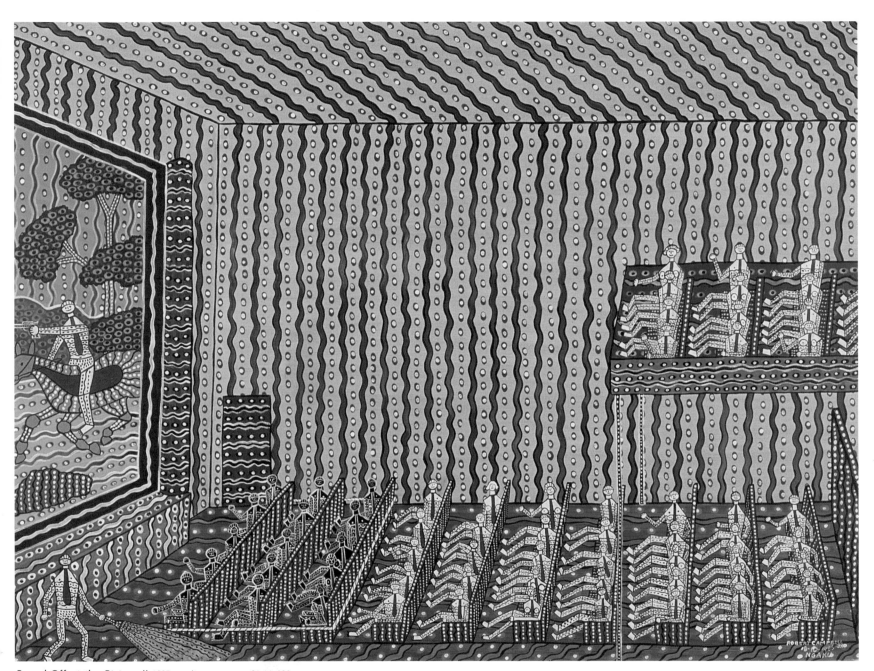

Roped Off at the Picture II 1987 acrylic on canvas 91 × 120 cm

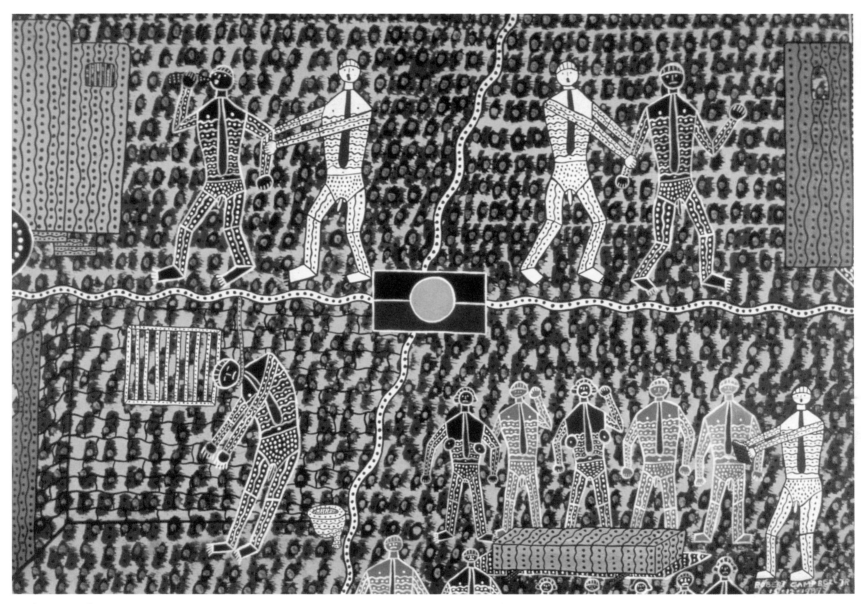

Death in Custody 1987 acrylic on canvas 81 × 120 cm

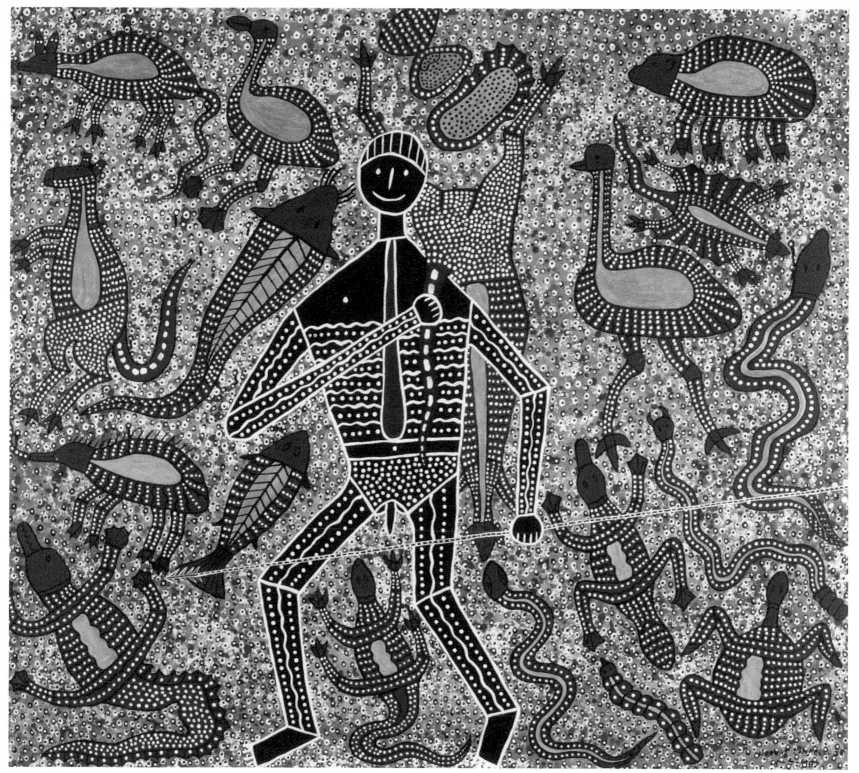

The Provider of Tucker 1987 acrylic on canvas 109 × 123 cm

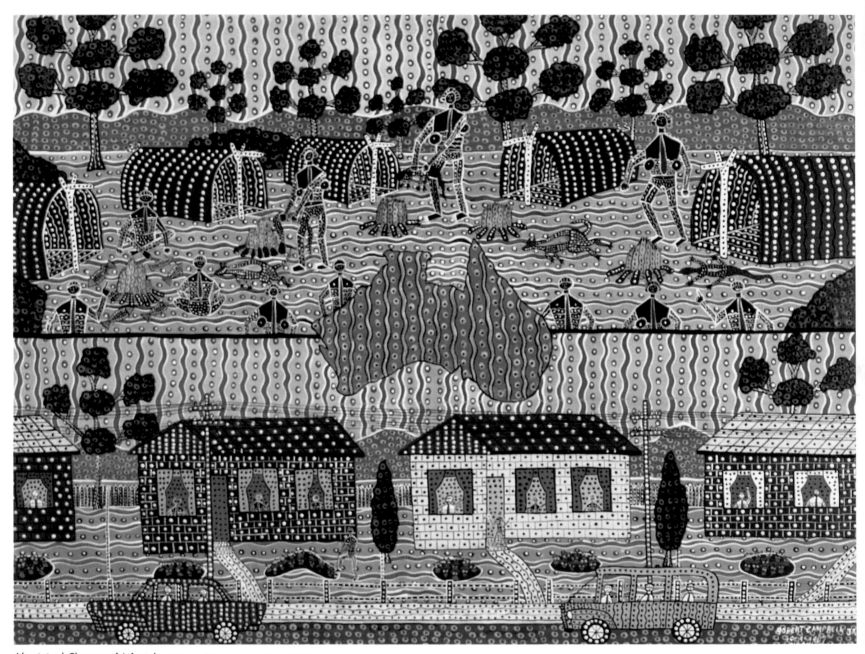

Aboriginal Change of Lifestyle 1987 acrylic on canvas 81 × 108 cm

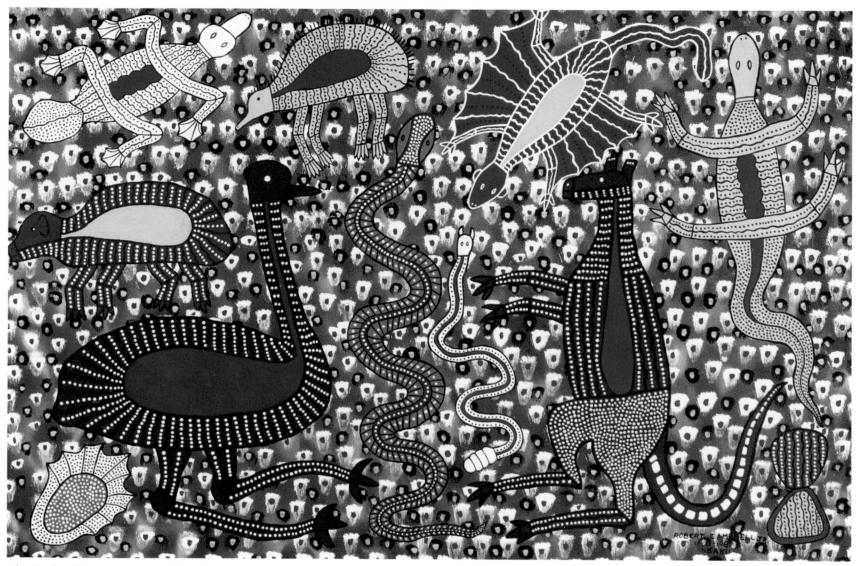

Abo Tracker 1987 acrylic on board 119 × 179 cm

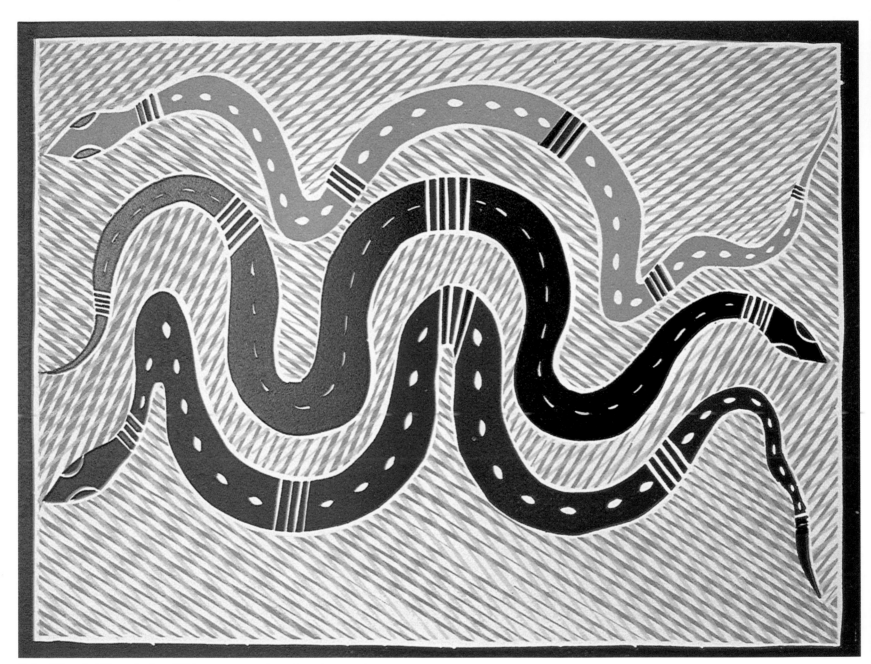

Muka Milnymirri **Three Snakes** *1987 linocut on paper 56 × 38 cm (paper size)*

banduk marika

As a child, Banduk Marika would sit by her father, Mawalan, in the beach camp at Yirrkala. She would light his pipe, then watch him painstakingly cover large barks with the mesmerising grids of crosshatched yellow, white, red, and black ochres of the sacred designs of the Riratjingu clan of northeast Arnhem Land. She was learning the stories and symbolic patterns that are now the basis of her own art of limited edition prints.

In recent years, women have carved the Riratjingu traditional designs on wooden sculptures of spirit figures, birds and animals, each a character in the important religious beliefs. After painting the surfaces the women use razor blades or knives to incise the fine patterns. It was this tradition that Banduk drew on to make her linocuts.

Banduk was born at Yirrkala Mission in northeast Arnhem Land in 1954, leaving for Darwin when she was eighteen. She later moved to Sydney where, in 1982, she made her first prints, exhibited the same year in the New South Wales Women's Art Festival.

During her years away from Yirrkala, she always retained strong links with her family and the traditional lands, basing many works on the subjects of her father's great bark paintings of the sixties, the Djankawu, the Wawilak Sisters and the Turtle Hunters.

The artist has held eight exhibitions of her prints — stark black-and-white or three-colour works. She has also developed a range of silk designs on fabric exploring themes connected to the elements — earth and water. Many of these are abstract, representing ripply lines or bubbles on the water.

Marika's initial style was very simple — strong images of goannas, snakes and birds. Her more recent designs are changing as she explores naturalistic scenes of birds or food gathering.

Between periods as artist-in-residence at Flinders University, Canberra College of the Arts and the Australian National Gallery, Banduk has also worked as an actress and film adviser on Aboriginal culture.

In 1988, after fourteen years in Darwin and Sydney, Banduk and her family returned to Yirrkala to live at the beach camp. She manages Buku Larnggay, the local Art Centre and Museum, and encourages the local artists to develop new art enterprises and outlets

for their work. During 1988, Banduk designed a limited edition print for the Australian National Gallery.

She continues to maintain her career as a printmaker but now finds it best to separate this aspect of her life. She, therefore, makes trips outside Yirrkala for concentrated periods of work with master printmakers in Sydney, Canberra and Melbourne.

Her work remains a continued expression of tradition, religion and the land.

The dancing and artwork is your whole life — you have to know your traditional artwork that ties in with the land and ties in with the creation, where your boundary is, how far your ancestral creator has travelled. It's all written in the art. That is what the traditional art means: owner to the land.

Yelangbara 1987 linocut on paper 56 × 38 cm (paper size)

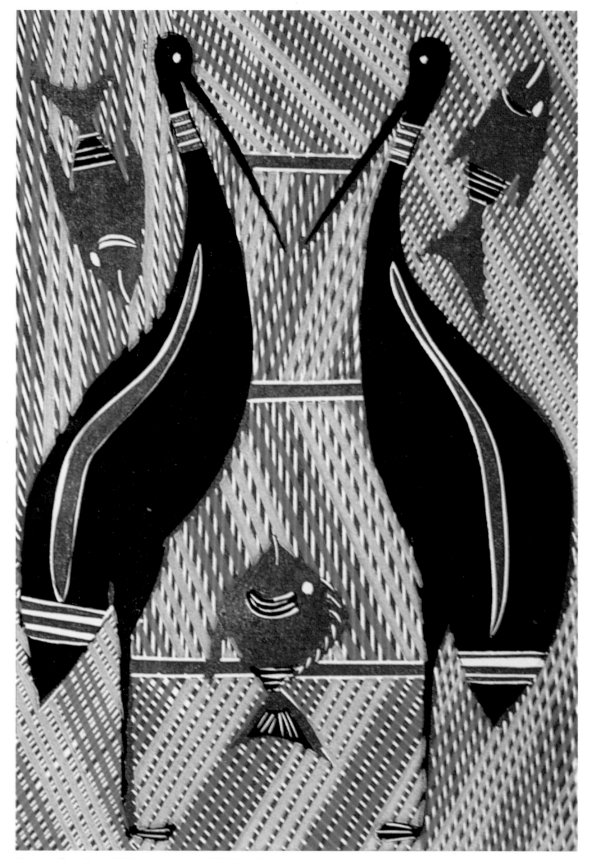

Marrma Gayntjurr *1987 linocut on paper 43 × 34 cm (paper size)*

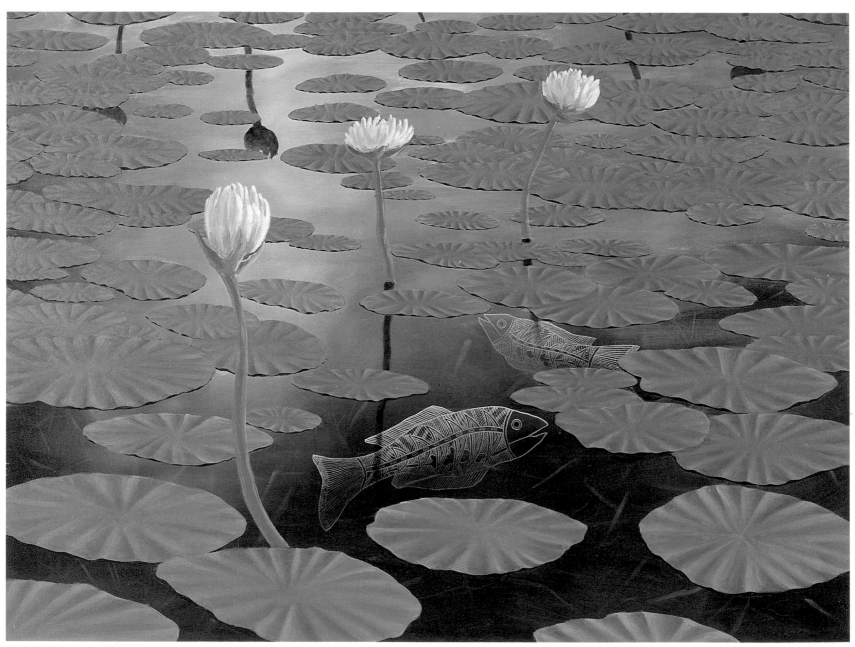

Fish and Lillies 1987 acrylic on canvas 90 × 122 cm

lin onus

GANADILA NUMBER 2

Lin Onus is a prominent Koori artist in Melbourne. He commenced painting in 1974 and is largely self-taught, yet his style and mastery of the medium of painting have ensured his central position among contemporary Aboriginal painters.

Lin left school at thirteen. For several years he worked as a motor mechanic and then with his father, Bill Onus, at his shop making art and craft souvenirs in the Dandenongs in Victoria. Over many years, interstate Aboriginal visitors including Albert Namatjira and actor Robert Tudawali, would stay at the Onus's family home. The family were closely associated with Aboriginal welfare and social development.

Bill Onus employed a number of artists in his shop and young Lin would often watch and talk to them as they worked. In 1973 while awaiting the bureaucratic processes of his application to join the fire service, he took up oil painting using a student's painting set that someone had left behind. He produced small landscapes and sold them at the nearby gallery. The artist has paid respect to the memory of two Aboriginal artist friends, Revel Cooper and Ron Bull, who were role models for him at the time and perhaps responsible for what seemed an obvious choice of landscape painting. His early work was photorealist landscape inspired by the valleys, ferns, creeks, and gullies of Sherbrooke Forest. He occasionally produced imagery relating to Aboriginal issues, although these were largely shown within the Koori community.

Lin Onus had his first exhibition in 1975 at the Aboriginal Advancement League, Melbourne, and has since held regular one-man shows in Sydney and Melbourne and contributed to joint shows with other Koori artists.

In 1986, as a member of the Aboriginal Arts Board, he made a visit to Maningrida that was to substantially change his outlook not only on painting, but also on life. The community at Gamerdi had a great impact. There he experienced the depth of knowledge about the land and the importance of symbols, pattern and design, as well as the formal process of passing on levels of knowledge.

But his visit was not only one of recognition of the power and strength of Aboriginal rights to land, and expression of this through art. He also saw daily symbols of struggle

Road to Redfern 1988 acrylic on canvas 60 × 120 cm

with the wider world — petrol sniffing, garbage, aluminium cans, buffaloes, and alcohol. He began to question the basic tendencies of his own art and changed direction. Onus has now made about nine trips to Gamerdi, and is learning the religion of the landscape from one of the master painters of the area, Jack Wunuwun.

His paintings over the last two years are striking. Elements of his photorealist background are juxtaposed with linear crosshatched patterns called "rrark" from the symbolic visual language of Arnhem Land. Thus we find in "Fish and Lillies" a paperbark billabong

Frogs 1988 acrylic on canvas 115 × 240 cm

complete with waterlillies painted meticulously as a tranquil, familiar Arnhem Land scene. Yet beneath the surface are two fish, with crosshatching — an immediate allusion to the presence of Aboriginal spirituality in every natural place.

In other works he has taken this development further, contrasting dramatically the "seen" and "known" elements of landscape. Both in technique and style, Onus is therefore symbolising his personal journey as well as the interaction of black and white cultures in the landscape itself.

Wirrirr Wirrirr — Rainbow Birds 1988 acrylic on canvas 115 × 240 cm

I realised that by the time I left school at thirteen I had absorbed everyone else's history and values but not those that were rightfully my own. The school system was insensitive and uncaring for Koories and I now realise that one of my greatest motivations is a fear of inferiority. Somewhere along the line I noticed Koories had few historical figures like Cochise, Sitting Bull and Geronimo, however, against this background, in 1977, I noticed a reference to a "murderous, guerilla fighter" called "Musqito" and after research my "Musqito" series commenced, marking a significant change of direction for me. Some people write the history, I can't write so I paint instead. My relationship with the Wunuwun family and my visits to Gamerdi are the most important influence on my painting now. For the first time I feel I am truly painting for my people, not for money, not for the influential "Gubbah" but for my community.

Gumingi — Magpie Geese 1987 acrylic on canvas 120 × 167 cm

Eternal Eclipse 1988 acrylic on card 62 × 76 cm

bronwyn bancroft

Bronwyn Bancroft is probably best known for her fabric designs and her work in the fashion and textile industry. She is a member of the Boomalli Aboriginal Artists Ko-operative and lives and works in Balmain.

Her outlet, "Designer Aboriginals", sells Bronwyn's prints, paintings, fabric, and clothing as well as work by other Aboriginal designers, printmakers and fabric workers. As a private business run by the artist herself, "Designer Aboriginals" aims to support and promote Aboriginal culture, both modern and traditional. Bronwyn Bancroft has exhibited her fashion textiles and clothing in Paris, and was one of the first contributors to the Aboriginal Medical Services Fashion Show — an annual spectacular for young Aboriginal designers.

Bancroft was not always an urban artist, businesswoman and fashion leader. She grew up in northwestern New South Wales and went to school at Tenterfield High School, completing her Higher School Certificate in 1975. She then travelled to Canberra where in 1980 she completed a Diploma in Visual Arts at the Canberra School of Arts.

Her efforts to support herself while studying art gave her important practical skills which she now uses in marketing and selling her works. She spent time as a layout artist in a print works and was also a photographic tutor. Although Bronwyn excells in her fashion work, particularly spectacular capes and "art clothing", her paintings show a joyful love of pattern and colour reminiscent of the dots, arcs and circles of desert paintings yet with an explosive mobile quality that is purely contemporary.

Whether painting a wall at Boomalli, helping to set up a show, or supervising and organising the work of young Aboriginal trainees at her gallery and shop, Bronwyn's life is busy and full extended. Her paintings and designs reveal an artist excited by the possibilities in life, eager to explore many new directions and to distil the full experience of her Aboriginal visual heritage into a personal expression of contemporary life.

Painting gives me great freedom. It enables me to express myself and my dreams. My work springs from deep within me, from my Koori ancestory. It is not necessarily a conscious expression of myself but more often than not an unconscious outpouring of my dreams. I hope to create a world of happiness, love and vitality and to give Aboriginal people reasons for optimism in an often pessimistic world.

Black Over White Under 1989 acrylic on card 66 × 78 cm

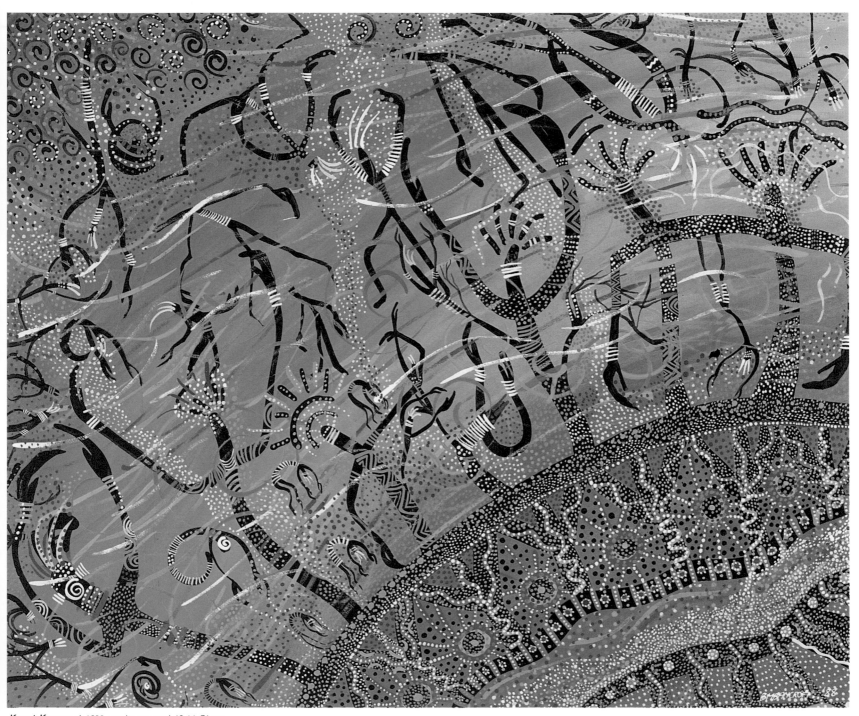

Koori Kompact 1988 acrylic on card 62 × 76 cm

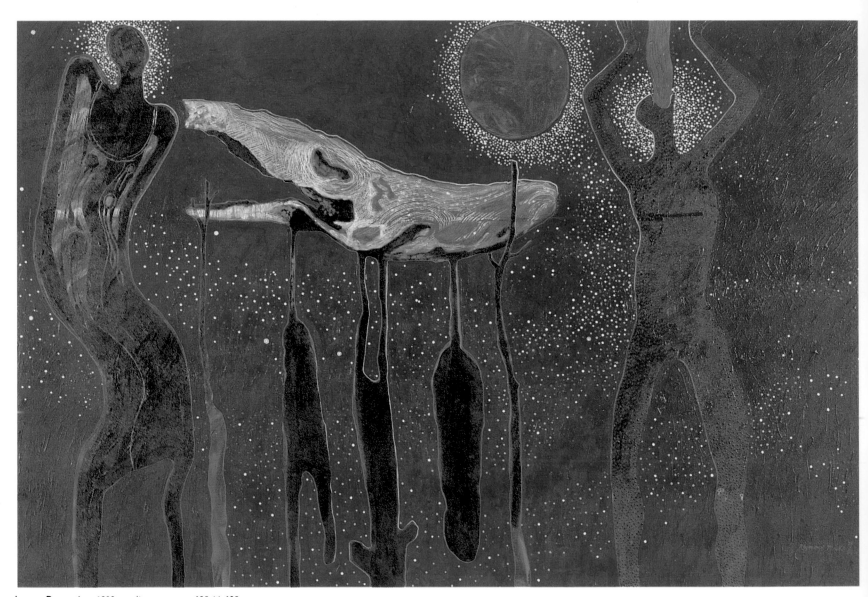

Laura Dreaming 1989 acrylic on canvas 125 × 185 cm

raymond meeks

ARONE

Raymond Meeks paints in acrylic, oil and lacquered inks, but frequently draws and prints. His six years of studies at various art institutions including the Queensland University of Technology, Kogarah College of Art, and Alexander Mackie College of Advanced Education, culminated in a Bachelor of Arts (Visual Arts) degree at the City Art Institute, Sydney. He has also studied at Mornington Island and at Yarrabah.

Art training has produced a complexity of references and styles. His first exhibited paintings were directly related to Aboriginal art history, with dream-related themes of Creation Ancestors. Other references in his work suggest the intense colour of European masters, such as Klimt or the dreamlike reveries of Chagall. His broad knowledge of Aboriginal visual arts is paramount, but in recent years the artist's personal search for his traditional Aboriginal origins has produced a clearly individual style and personal imagery.

Raymond was born in Sydney in 1957 and returned with his mother to Cairns as a baby. During his early years he lived with his mother and other family members shifting from town to town. The influence of his mother was very strong. "We had lots of relatives so we just moved from town to town visiting. One of my earliest memories is of when we used to live on the outskirts of Cairns by a mangrove swamp. We lived with my grandparents, aunties, uncles, and cousins. It was a good time, we Meeks were a big mob and we ate well; things like bandicoots, scrub hens, fish, mussels, and oysters."

Following the death of his mother, Raymond moved to live with his uncle, a railway worker, and his family in El Arish, a town one hundred miles south of Cairns. He attended school in Tully. His grandfather shared his room. Retracing the stories and images his grandfather wove for him in the evenings they spent together is one of the important current concerns in his life. "Ours was a crowded household with all those children and we had this little railway cottage. He used to talk to me a lot. He was brought up in the old ways, I believe he was initiated, but I'm not sure."

His grandfather would talk about childhood events often interlinking the past with the present, stories of the bush and the sounds of the bush were often told. Raymond feels that his imagery comes from these experiences of childhood in North Queensland. Although his

memories, in his words "are always fogged and dreamlike", images still come to him in his dreams. Dreams are a very real part of the creative process in a similar way that traditional Aboriginal people speak of the word "Dreaming" as the state in which they communicate with the great Creation Ancestors.

Raymond Meeks, although primarily a painter, has an exceptionally busy career as a graphic designer. He has designed book covers, children's illustrations, posters, fabrics, and recently, the stage designs, posters, banners, laser show, and written materials for the 5th Festival of Pacific Arts held in Townsville in 1988.

Raymond's love of the tropical rainforest, his early life in Cairns, Tully and nearby regions has meant that he feels his future is in North Queensland. He has taught the Aboriginal and Islander students in the TAFE course at Cairns and acts as an advisor and mentor for younger students.

The discipline at art school, which drawing classes imposed, has been important for Raymond Meeks, although his most recent black-and-white brush "drawings" have a freedom and simplicity more reminiscent of Chinese painting than formal art school drawing.

In 1988 Raymond was formally given the name Arone, white crane, by Thancoupie and members of the community at Napperanum in a traditional Aboriginal "baptism" ceremony — an immensely important event for the artist.

I believe that art is a language for interpreting who you are, and I can't find any satisfaction other than painting. I have a natural need to interpret what I feel and see. I feel it in my heart and I can do it. It's like knowing an emotion and it is very important to record it. Aboriginal people have always had a vast, rich culture and I am part of this.

There are many things which are too numerous to mention about the treatment of Aboriginals but through my art I have identity and strength.

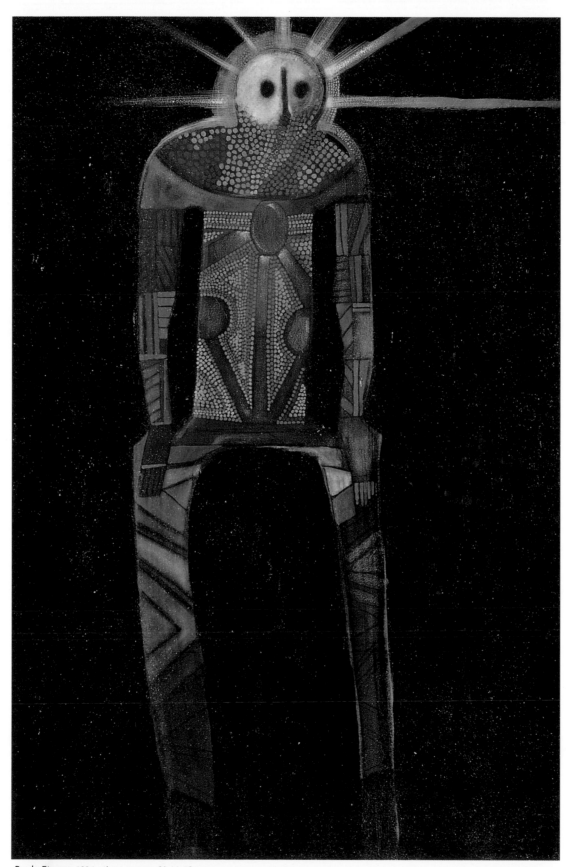

Bush Figure 1984 oil on canvas 93 × 63 cm

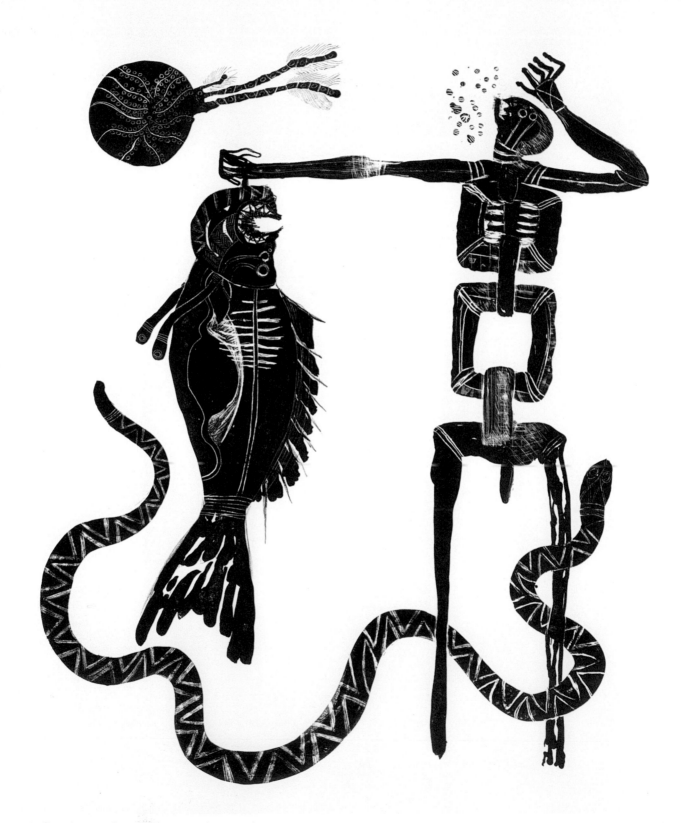

Argoonie Doowie 1988 silk screen 56 × 76 cm (paper size)

Healing Place 1988 silk screen 76 × 56.5 cm

Expo 88 1988 pastel on paper 56.5 × 76.5 cm

fiona foley

Fiona Foley is one of the founding members of Boomalli Aboriginal Artists Ko-operative in Sydney. Her work has received prominence within the inner city urban art viewing network, although her childhood and background are in coastal Queensland. She is a descendant of the Butchulla people of Fraser Island.

Her current works, often called paintings, but which she herself refers to as drawings, are executed in pastel and crayon, inks and pencil. They strongly reflect her involvement with space and form, and have a strength perhaps derived from her appreciation and involvement with sculpture as a student.

Fiona Foley's school years were spent travelling between Hervey Bay and Mt Isa in Queensland, and Hornsby in Sydney. From 1982, her tertiary education for the next six years took her from art studies at East Sydney Technical College to the Sydney College of Arts.

Fiona refers to that period as "a minefield of right wing students, ethnographic academics and pure frustration, educating the masses about east coast Aboriginal art and culture."

Since 1985 Fiona has travelled extensively over her traditional country of Fraser Island and has made numerous trips to Arnhem Land. In this period "my art has developed and will continue to grow". She first visited Ramingining on an Aboriginal Arts Board grant. While there she worked in association with John Mundine,the local art advisor, and participated in lengthy ceremonies well into the dawn.

The layout of seating and action at all Aboriginal ceremonies is carefully planned along kinship and therefore land ownership principles. In her recent work exhibited at Roslyn Oxley Galleries, Sydney, Foley has distilled these arrangements and her own experiences into strong, deceptively simple statements. Her capacity to formalise and to simplify the relationship between forms and to therefore codify meaning about Aboriginal matters is evident. Independent shapes and geometric figures are placed on dark plain backgrounds of earth colours. Snake-like shapes enter ceremonial grounds and face people seated in a half-circle.

At the side, symbols for shelters could also represent headdresses worn by men. Each work relates to a particular incident or set of circumstances. There is a strength and a clear rhythmical tie between the shapes in her works.

As well as drawing and sculpting in her own studio, Fiona has in the past participated in a number of important group exhibitions and community events. A prominent member of early Koori art exhibitions in Sydney, she has designed a *survival poster* for the Aboriginal and Islander Dance Theatre, Sydney; and has worked on murals at Cleveland Street High School, and Sydney University Settlement.

The artist's early works were soft, elegant drawings and collages on paper constructed from natural found objects often related to the sea. Her growing concerns with form and women's history and strength now permeate Foley's work.

Fiona Foley's symbolic abstract art and gentle personality belie the political effect she has had in galvanising urban Aboriginal artists. She is deeply concerned with the history of Aboriginal dispossession and takes an active role in educating the public not only through her art but through political activity. During 1988 she was a leader in the anti-bicentennial activities, of particular note was her moving speech mourning the lost people of Fraser Island, which was given at the Biennale Forum associated with the Aboriginal burial pole memorial at the Art Gallery of New South Wales.

My earliest memory of my art during childhood is winning fifty cents for a drawing competition in 1st Grade. It was a multi-coloured oil crayon of "Jane" with a skipping rope. The other important influence on me growing up was a book titled "The Legends of Moonie Jarl", written by my Great-Uncle Wilfie and illustrated by my Great-Aunty Olga. It was published in 1964. I remember Uncle Wilfie's presence, around the old Queenslander house we used to live in at Urangan, Hervey Bay, and to this day I still hold dear the stories he told about his introverted beach-combing, his literary skills and his service overseas on the Kokoda Trail — hence his nickname, "The Kokoda Kid".

My drawings are event-orientated, it may be a place where I've been or something that has taken place, and it could be difficult to ascertain the meaning of these symbols in my art, unless you were to speak to me.

All Aboriginal art in this country is political whether it is an abstract bark painting explaining the title deeds to land ownership or a recognisable symbol like the land rights flag in an oil painting.

Gunababi 3 1988 oil crayon on paper 56.5 × 76.5 cm

Dugong 2 1988 ink and pastel on paper 56.5 × 76.5 cm

Barunga 1988 pastel on paper 56.5 × 76.5 cm

Men's Business 1988 oil crayon and pastel on paper 56.5 × 76.5 cm

Gunabibi 1 1988 pastel on paper 56.5 × 76.5 cm

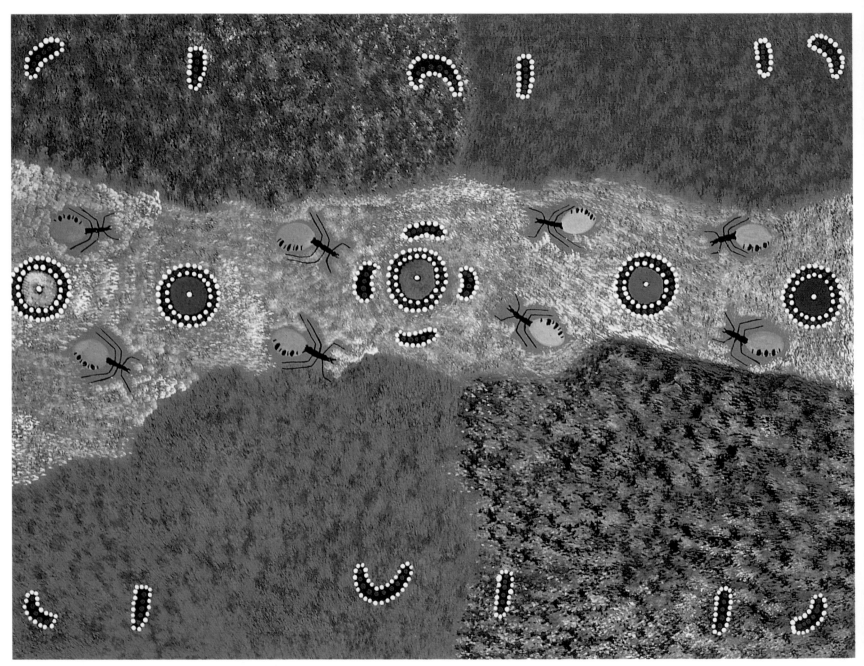

Honey Ant Dreaming 1988 acrylic on canvas 90 × 120 cm

barney daniels tjungurrayi

Barney Daniels Tjungurrayi was born at Haasts Bluff about forty years ago. As a full member of the Luritja people his early life was spent learning traditional ways of survival, law and ceremony.

Although Daniels moved to Papunya when he was about ten years old, the family constantly travelled. For a short time he went to school at Halls Creek, Western Australia and later, as a stockman for five years, he worked on a cattle station with other Aboriginal men. His job was to bring in wild brumbies. On one such expedition a brumby kicked him in the face and, although he was hospitalised in Perth, he still bears the scars of that incident. He spent time at Derby and Wyndham, Western Australia, and about nine years ago moved to Alice Springs where he still lives and paints.

Daniels recalls that the first artwork he made to be sold was on wooden boards. "First I was tattooing boards", a phrase he uses to describe the poker work technique of decoration commonly used by stockmen. He commenced acrylic painting about three years ago when the Alice Springs Gallery provided materials.

Barney Daniels's paintings are traditional in theme in that they are mainly concerned with snake dreaming at Central Mount Wedge, but as seasons change his paintings also change dramatically. Many are about finding water, a constant preoccupation of his childhood, or about bushfires. A highly experimental artist, he is the first of the desert school to develop the stippled rough brushwork technique which he uses to create atmosphere, particularly around waterholes, or to express fire. He is gradually achieving particular distinction as one of the most innovative of the new desert artists.

In 1988 he took up a commission from the Australian Bicentennial Authority to produce contemporary Aboriginal designs on television sets and chairs. This work toured in the Australian Bicentennial Exhibition. His art was recently exhibited at the Gauguin Museum in Tahiti and he is represented in many major collections.

I enjoy painting. I really like to sit down and work. I have always worked. Nobody taught me. I do it my own way . . . but I would still prefer to be a stockman.

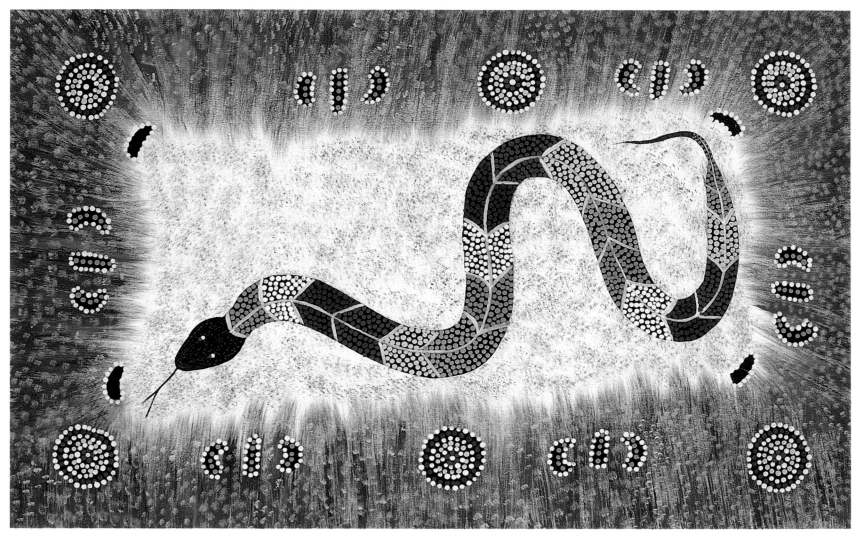

Bushfire and Snake Dreaming 1988 acrylic on canvas 60 X 120 cm

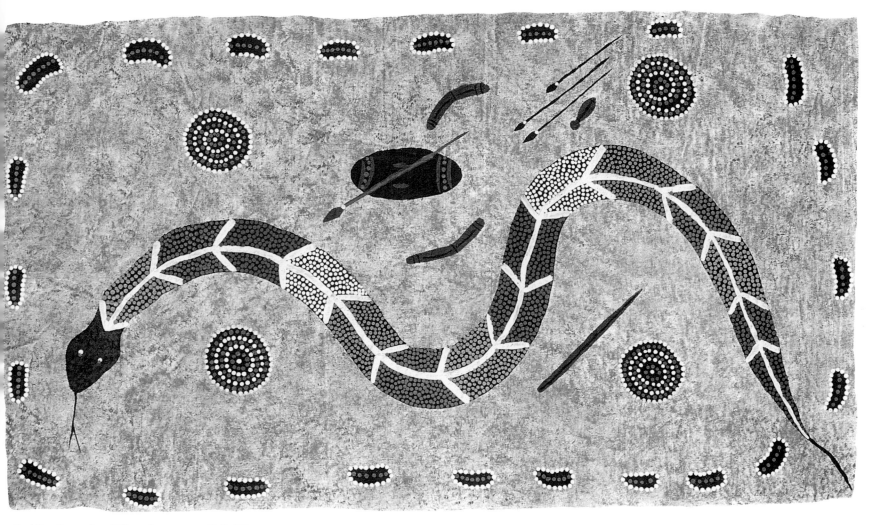

Bushfire Dreaming *1988 acrylic on canvas 90 × 165 cm*

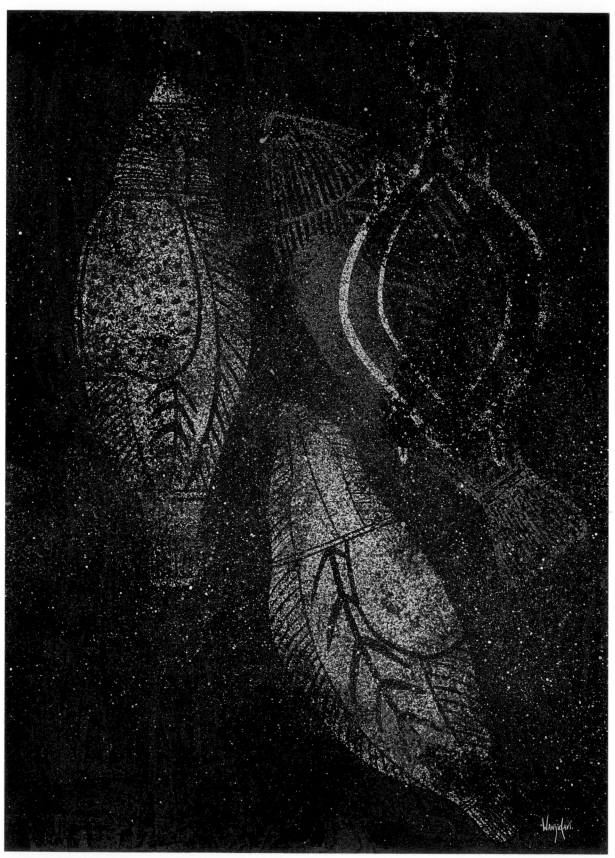

Barramundi Motif, Cape York 1988 acrylic on paper 96 × 70 cm

w a n j i d a r i

LEANNE REID

Wanjidari was born in Townsville, a member of the Wadja Wadja people. She spent her childhood in the Woorabinda district, west of Rockhampton.

Although her European name is Leanne Reid, since graduating in art from the Cairns TAFE College, Wanjidari uses her tribal name exclusively. Translated, it means "white flower of the bush".

As Wanjidari moved from place to place as a child her education was disjointed. Although she barely completed Year 8 at school, she won an important art competition while there which gave her confidence in her creative abilities and the determination to develop them.

She enrolled in the Aborigine and Torres Strait Islander Associate Diploma of Art course in 1986 and over two years learnt skills in printmaking, batik and other media. The subjects she chose always expressed her knowledge and understanding of traditional culture.

Wanjidari now exhibits at The Upstairs Gallery in Cairns as well as interstate. "After those two years I knew that art was my life and that I wanted to be part of a group of young Aboriginal artists who are keeping alive the traditional art of our people."

The trips the students undertook to the Laura region where they visited extensive rock galleries as well as the engravings and cave paintings on Stanley Island have influenced her most in terms of imagery and technique. In addition, her uncle from Lockhart River told her many stories about her past, her people. She was able to link this understanding of the traditional way in which Aboriginal people had expressed their creative life with her own family's heritage.

Recently, Wanjidari has begun a major series of paintings inspired by rock painting. In these she recreates the layers and stencilled techniques of the rock art galleries. Her works have an ageless and timeless quality, yet are strong contemporary expressions of the oldest art tradition in the world.

My uncle told me many stories about my family. I want to know more about my past and I want to tell stories about my people in my drawings and paintings.

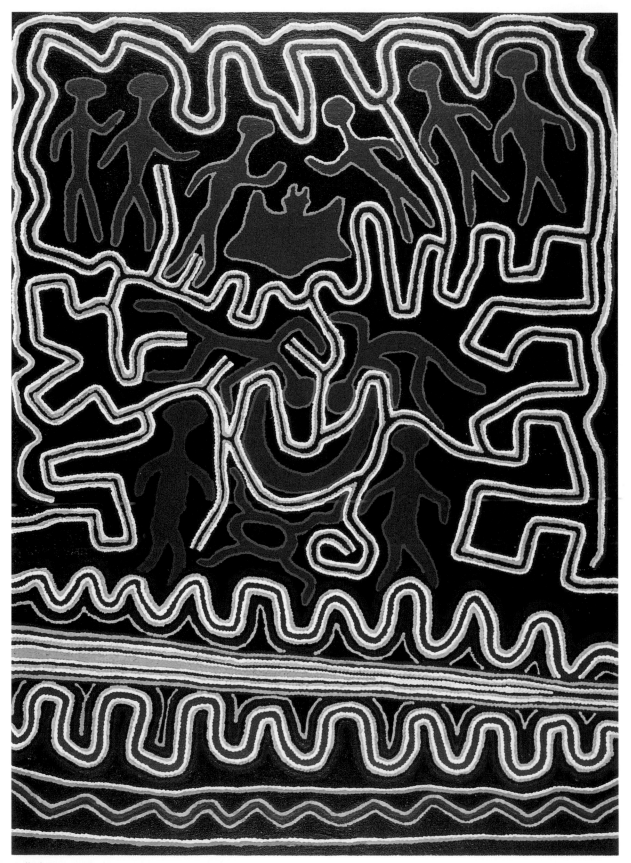

Kalkalwurtu 1988 acrylic on canvas 76 × 55.7 cm

jimmy pike

Jimmy Pike was born into the Walmajarri people of the Great Sandy Desert of Western Australia. Today he is centrally positioned as a prominent contemporary artist in style, colour and media.

The artist was born about 1940 in the Great Sandy Desert and his early life was spent hunting and gathering with his family, moving from waterhole to waterhole according to the seasons. During these years he absorbed and learnt ceremony, the country and the dreaming stories. While travelling north with his family when he was a boy, he first came into contact with white people and soon after went to Cherrabun, a cattle station near Fitzroy Crossing where he became a stockman.

His first experiences of expressing his country through traditional designs were as a woodcarver. Along with other men, he made boomerangs, hooked spears, fighting sticks, and shields, carving intricate patterns denoting dreaming tracks and legends about the country. These were sold through local outlets and to white visitors. He started painting and making prints in 1981 in Fremantle prison. His teachers, Stephen Culley and David Wroth, encouraged his remarkable talent and, after his release, formed the successful design partnership ''Desert Designs'' which has catapulted Pike's designs into prominence in the fashion industry.

Most of Jimmy Pike's work is about the land to which he is spiritually bound. The themes are mythological events which pay homage to the ancestral creative beings and the dramas between animals, spirits and people in the creation of his country. As well he incorporates attitudes and incidents in contemporary life — helicopters, motor cars, or recently a ship, ''Kartiya Boat'', a commissioned work for the Australian Bicentennial Authority depicting the first ship to bring white people to this country.

Although the media he has adopted, acrylic paints and printing inks, is modern, the subjects and content of his work are of another time phase — the spiritual nature of the Aboriginal landscape, which is a continuous link with its very creation.

Meandering lines and grids, particularly the square meander, are clearly inspired by the traditional square patterning of the Western Australian Desert carved weapons. Daily

images of camp life — snakes forging their way through the hills and rocks frightening people or devouring them, or children's stories told around the campfire teaching correct behaviour — are all part of Jimmy's themes.

His colours are intense, dramatic; his compelling and sinuous lines draw the viewer into or across the canvas. Sometimes the shimmering, radiating quality in his painting is intensified in the brilliant prints made by the "Desert Design" graphic team in Fremantle, from Pike's linocuts.

The artist now lives with his wife back in his desert country. His "studio" is in the open air — a roughly constructed yet practical table and a simple shade, which, depending on the seasons, may be a tarpaulin or may be made of wire and brush. Again, depending on the seasons, he sleeps under the stars or in a tent, enjoying the bounty of the bush by supplementing his ordinary diet with plenty of bush meat and fruit.

My work is painting and drawing. Telling stories from Dreamtime, and where Dreamtime people been travel through my country. They been putting the Law for real people today, wherever they are. That's what I paint.

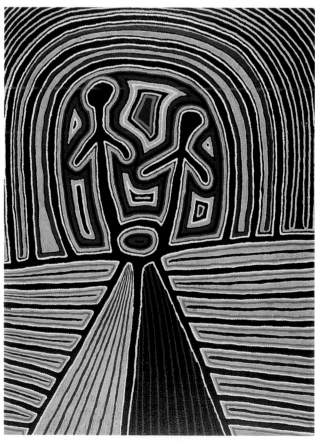

Pitingkaji and Wuta 1988 acrylic on canvas 76 × 55.7 cm

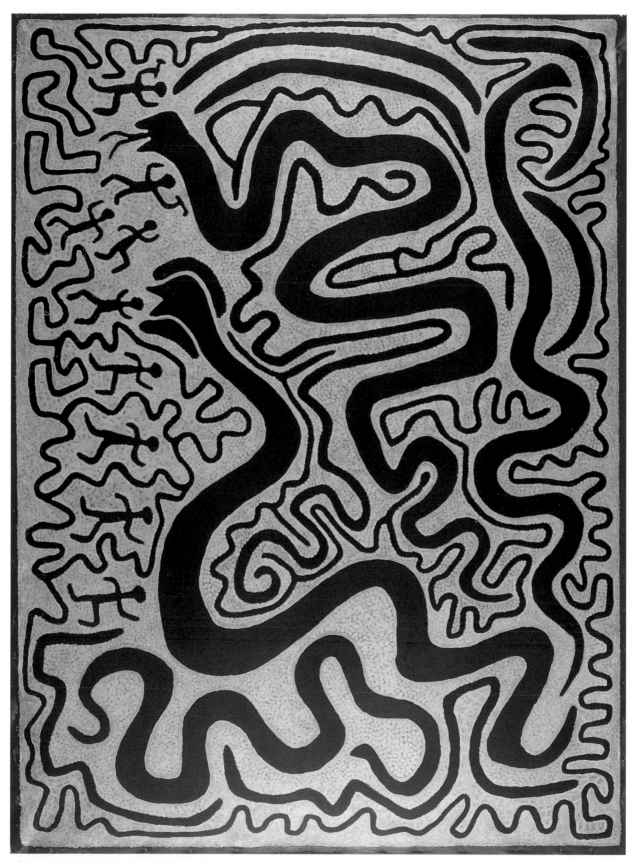

Kalpurturlu Yagangarni. A Real Story 1988 acrylic on canvas 165.2 × 119.7 cm

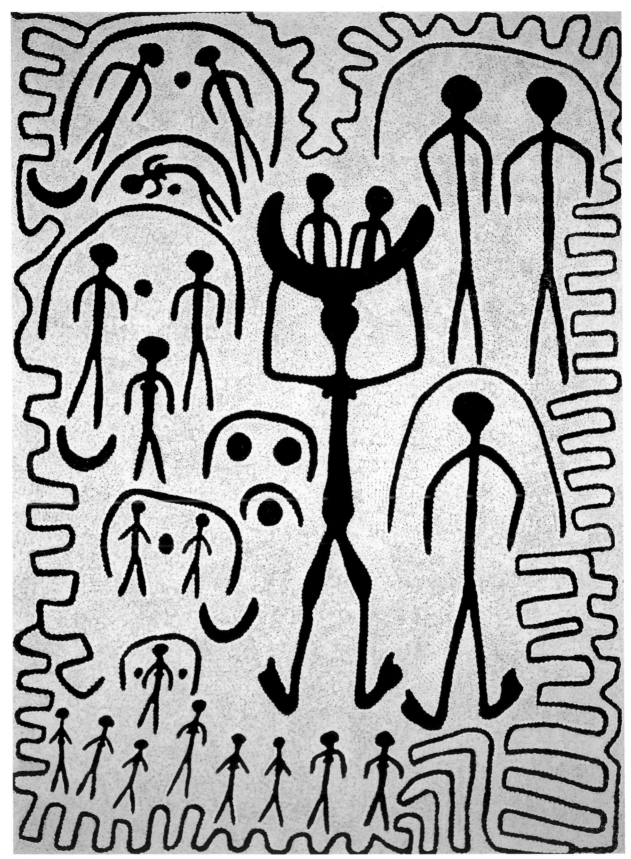

Junjuwarnti Pukapuka 1987 acrylic on canvas 164 × 118 cm

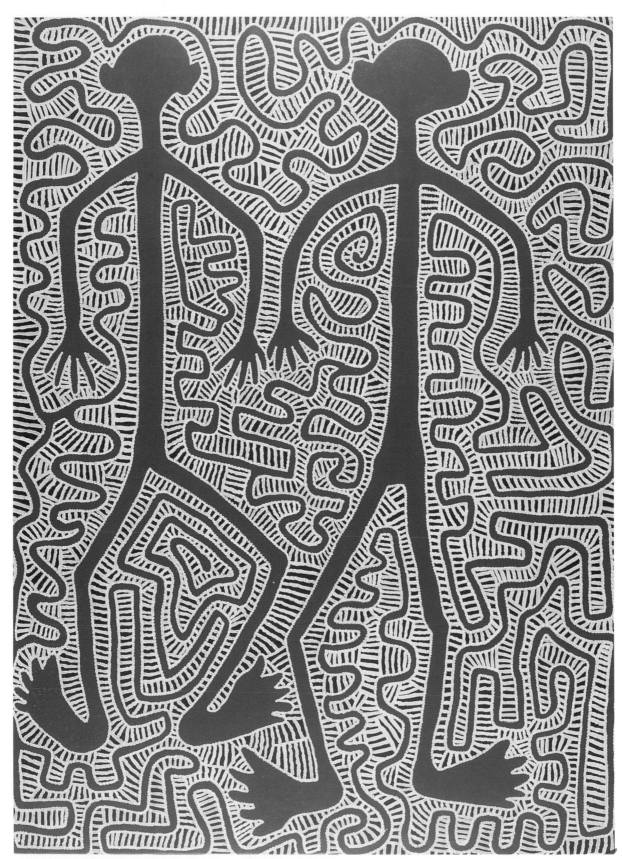

Kurnrumaru and Parnaparnti II 1987 acrylic on canvas 164 × 118 cm

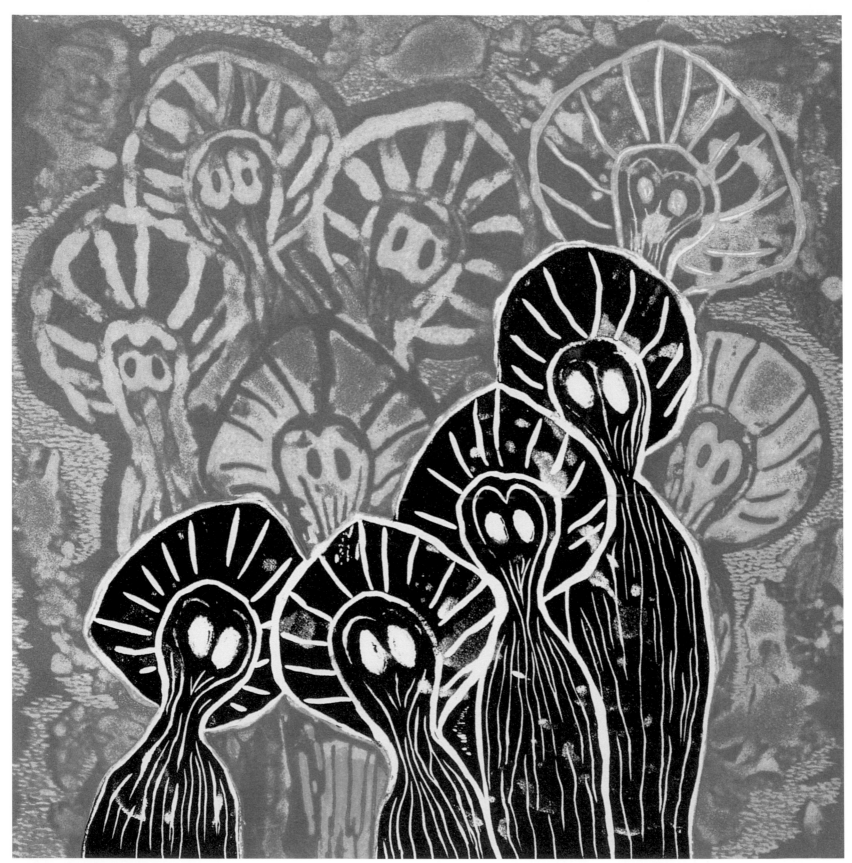

Watching 1988 linocut on paper 25 × 25 cm

heather walker

Heather Walker was brought up and educated in Rockhampton, Queensland. She attended the Cairns TAFE Aboriginal and Islander Art Diploma course where she found batik and linoprinting the most sympathetic media in which to express Aboriginal and Islander contemporary themes. Her workshop-studio is situated in the rainforest at Lake Placid, Cairns, a compatible, supportive, highly productive environment in the tradition of artists' family compounds in many other traditional societies. She shares this with her sister, Jenuarrie.

Heather Walker lived a full life before taking time for herself in which to explore her artistic talent. She married early and brought up her family along the way. She has always preferred to be self-employed. With her husband she owned and operated a successful commercial cleaning business for many years in Mackay, and also a restaurant.

Heather's work has been exhibited by Aboriginal Arts Australia as well as other private galleries including Grafton House Galleries, Cairns; Tynte Gallery, Adelaide; and Nikina Gallery, Brisbane. In 1988 she received a most important recognition of her work when she won the Fifth National Aboriginal Art Award for the best work in mixed media. This is an annual award given by the Museum and Art Gallery of the Northern Territory. Her winning linoprint was also acquired by the Australian National Gallery in Canberra.

Much of the artist's imagery derives from Cape York rock art. This great series of galleries is in the Laura sandstone belt in southeast Cape York. Here hundreds of painted galleries up to thirty metres long have been recorded. Much of the art depicts human figures and spirits, as well as plants and animals. In a sense it is the physical record of extinct animals, changes in plants and human preoccupations both temporal and spiritual over centuries. The Quinkin figures predominate and these spirit entities — mischievous characters that remind present day people of the power of the bush and the presence of spirits everywhere — frequently appear in Walker's work. However her art explores many other themes and departs, not only in medium and function but also in imagery, from the purely traditional.

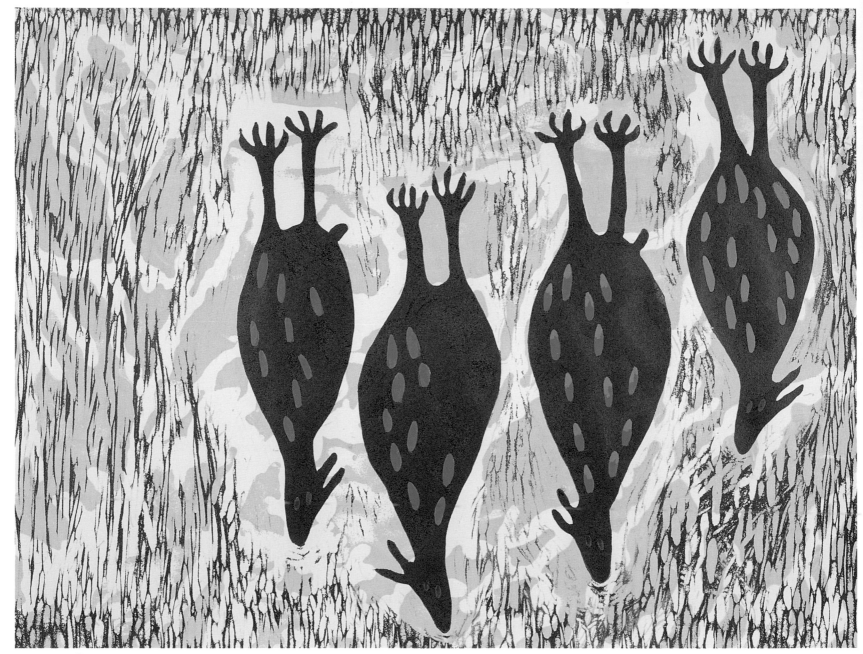

Fruit Bat Gallery 1988 linocut on paper 37.5 × 50 cm

Rock art is, generally, two dimensional and basically naive in style. By using subtle backgrounds of muted texture in my linoprints, and the layering of colour through the images, I am adding another dimension. This works as an echo and gives resonance to the otherwise flat images.

It is a style I have enjoyed developing and it is most encouraging when other people enjoy my prints also. I feel that my contemporary approach to Aboriginal art is in harmony with the spirit of the traditional artists.

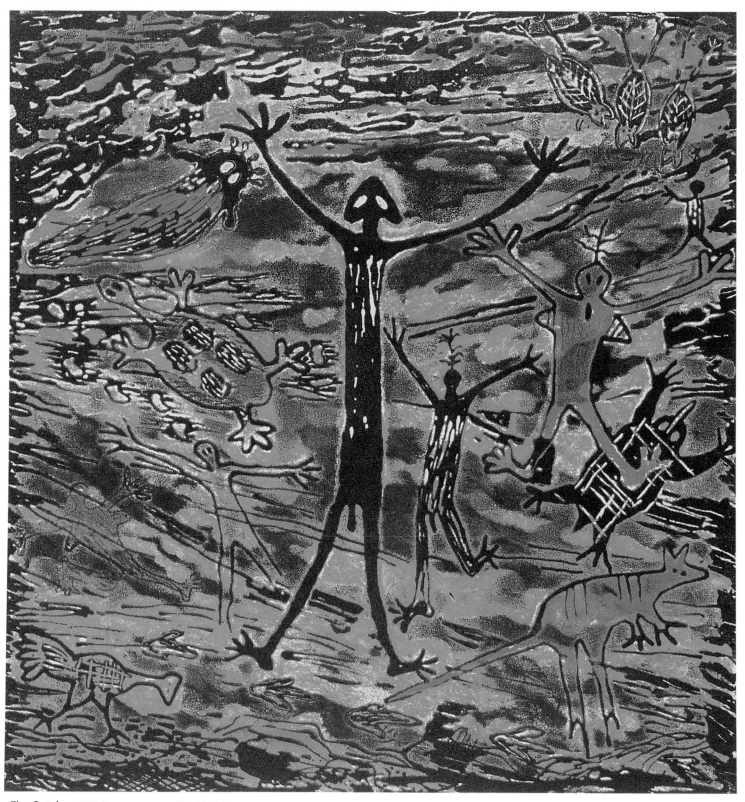

The Quinkins 1988 linocut on paper 32.5 × 30.5 cm

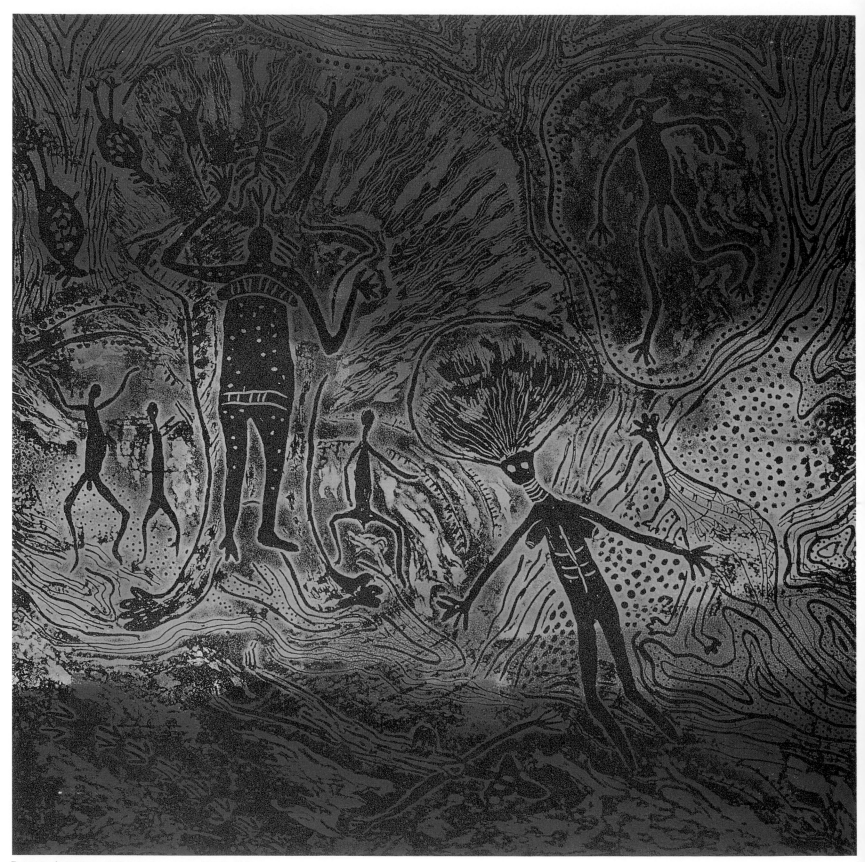

Totemic Ancestors *1988 linocut on paper* 42.5 × 42.5 cm

jenuarrie

JUDITH WARRIE

Judith Warrie was born in Rockhampton in Central Queensland and educated at Frenchville State School until the age of thirteen. She did not study art until she was in her early forties. She subsequently took the professional name of Jenuarrie. Assisting her mother in supporting the family, Jenuarrie spent much of her early life working in a range of minimum wage jobs.

Her mother has been a great inspiration to Jenuarrie, both in her outstanding efforts in raising the family, and her artistic talent which was passed on to Jenuarrie, her sister and brothers. "I think we inherited artistic qualities from our mother as crafts have always been a natural part of our daily lives."

Until she entered the Cairns TAFE Aboriginal and Islander Arts and Crafts course, Jenuarrie maintains that all her thoughts and ideas were western. But through art and through the re-examination of her own cultural heritage she has become a dynamic and prolific Queensland contemporary artist.

She lives and works in a "family compound" with her sister, Heather, and their husbands. They share a large and productive studio complete with printing press, space for batik and a separate ceramic studio. Ceramics, batik and printmaking are equally important aspects of Jenuarrie's work. She first became interested in clay through a Melanesian tribal pottery course in Cairns known as the "Down to Earth" Potters, and now makes pottery and ceramic sculpture to complement her two dimensional work.

The Australian National Gallery purchased Jenuarrie's art while she was still a student, an indication of the promise that she then showed. Since graduation from the TAFE Aboriginal and Islander Arts and Crafts School in Cairns Jenuarrie has benefited from indigenous people's cultural exchanges, in particular with Maori artists. In 1988 she was invited by the Maori and South Pacific Arts council to visit, speak and exhibit in New Zealand. This interaction has reinforced her commitment to develop a prominent career expressing contemporary Aboriginal themes and issues. "Amongst the Maori and Hawaiian artists there is a strong contemporary art movement. Their struggles for recognition are identical to the contemporary Australian Aboriginal artist, as most people have preconceived ideas of what

Aboriginal art should look like." Jenuarrie pays tribute to the importance of the interaction with other artists in the investigation of their shared heritage, and the supportive environment for creativity.

Her prints, pottery and batik principally draw their inspiration from traditional Aboriginal rock art, in particular from the Laura caves of Cape York, as well as the engravings on Stanley Island in far North Queensland.

In 1987, she was awarded the Andrew and Lillian Pedersen Memorial Prize for Printmaking, an annual prize awarded at the Queensland Art Gallery.

My artwork depicts images that are very old and hold special significance. It is as if my artistic decisions are guided by my ancestors, for I never work to a prepared plan.

My contribution towards supporting our people is to become recognised as an artist and to promote and develop the art of the indigenous people of Australia. This opens up discussions about our heritage and culture and it can change the ignorance and lack of resource material that has been a problem and has created many of the conditions we face today.

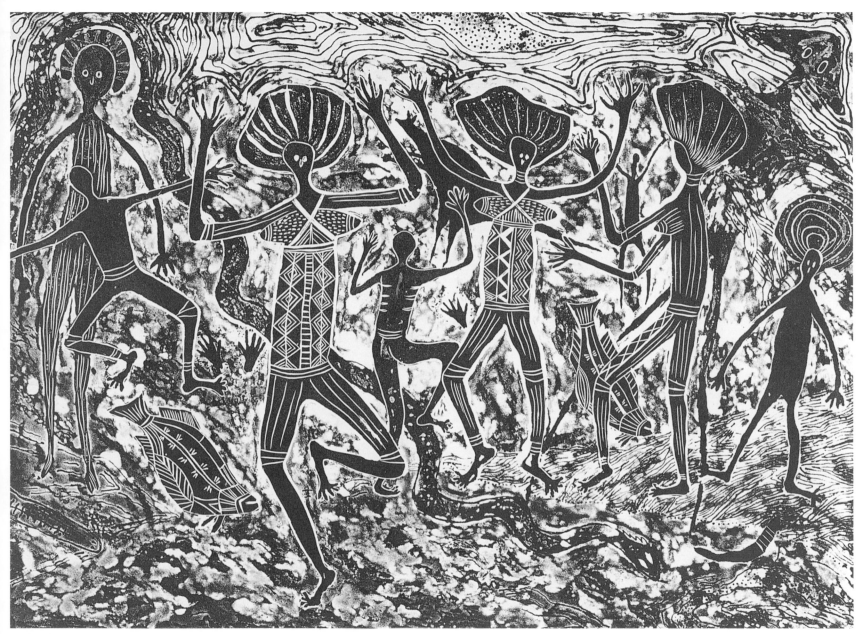

Mythical Dancers 1988 linocut on paper 42 × 57.8 cm

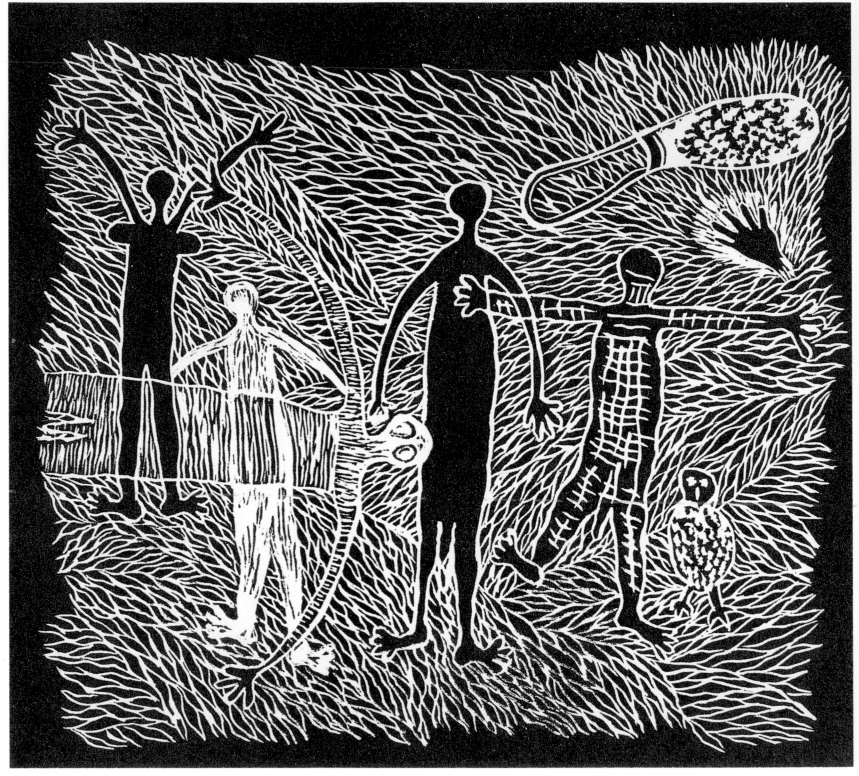

Sorcerers Ritual 1988 linocut on paper 16.5 × 18.3 cm

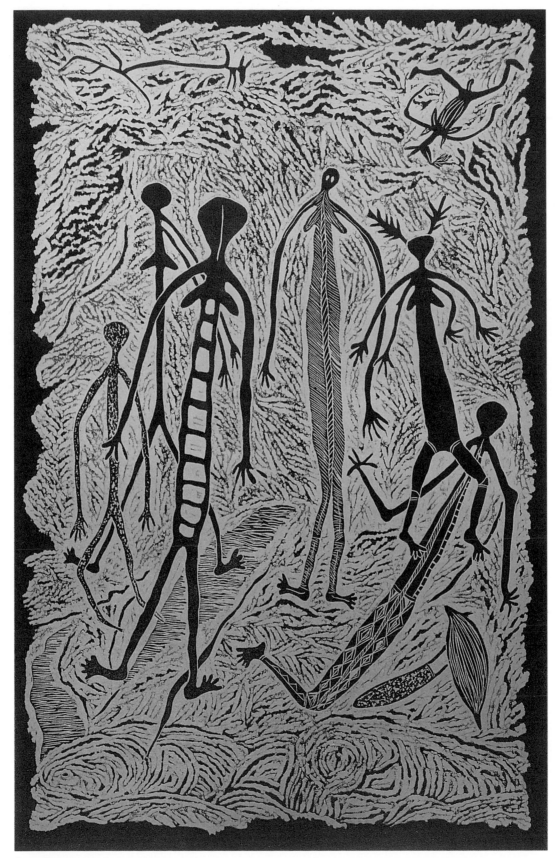

Spirit Beings 1988 linocut on paper 47.5 × 30 cm

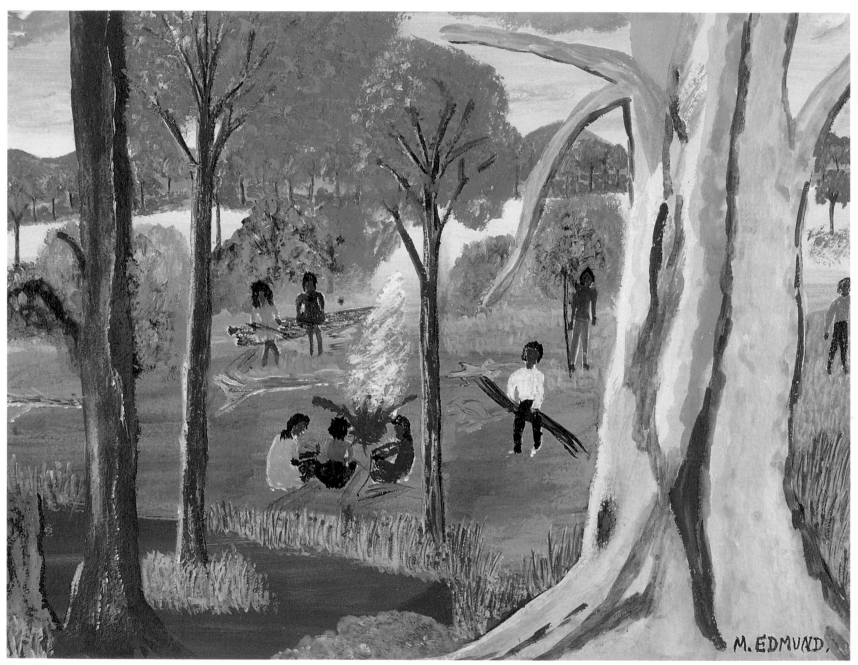

Camp Scene 1988 acrylic on paper 39 × 28 cm

mabel edmund AM

Mabel Edmund became an artist relatively late in life after playing a prominent role in public life in North Queensland. Her mother was Aboriginal and her father was a descendant of the Kanak canecutters brought here from the New Hebrides late last century. She has held a seat in local government as a shire councillor on the Livingstone Council and has travelled to Cambridge University representing Australia at a world conference on art and communication. Her commitment to her people spans decades of work in social welfare organisations. During that time she says her artistic vision had to wait.

In 1986 Mabel Edmund was awarded the Order of Australia for her pioneering work for the Aboriginal and Islander community.

By this time she was a mother of six and a grandmother of fifteen. It seemed the right time to give in to her desire for self expression through art, so she enrolled in the TAFE Aboriginal and Islander two year art course in Cairns. This is a unique educational situation in Australia, a course designed specifically to meet the needs of Aboriginal and Islander students from Queensland. Her teachers included Anna Eglitis, Tom Vudrag and Gary Andrews.

The artist's life informs her art and her aspirations. In common with other Aboriginal activist grandmothers she has spent the main part of her life bettering conditions or fighting for Aboriginal rights (like Kath Walker who has recently turned towards drawing in preference to public speaking). She can now take the time to reflect and show her love of the traditional way of life in paintings, batiks, prints, and a variety of media.

Mabel's paintings have the vitality and freshness of the best expressive naive art. Many are joyful paintings of daily life. The works offer accounts of North Queensland Aboriginal life — camping in the bush among tall forest trees, children swimming with joyful abandon in a waterhole among palm trees and blue water. Their echoing sounds can almost be heard as they laugh and splash in the water.

Edmund has made a particular study of her own Kanak heritage, a subject frequently ignored by the wider Australia. She has recorded the history and reminiscences of daily life from many who recall their grandparents telling of the conditions of slavery on the cane

fields. These stories are included in her autobiography, which is in preparation. Mabel Edmund recently moved to Nerimbera, north of Rockhampton, where she now works full-time as an artist.

Her landscapes clearly come from an Aboriginal perspective. They have an immediate impact and, like the paintings of the late Dick Roughsey, they show the integrated knowledge of the country learnt first-hand as a child. Many show ancient cave paintings, Quinkin spirits and other important images of Aboriginal spirituality from the far north. But her work also celebrates the lushness of rainforests, open bushland and the flood plains of the Cape. The pictures bustle with life. There are emus and brolgas and bright yellow goannas climbing trees and people interacting, busy with daily tasks.

I enjoy art as a form of communication and as a means of recording history and culture. I am fortunate in that I love lots of colour, and have the ability to use colour and line to my advantage. I paint most of my pictures from memory of things that have happened in the past, and places that I have seen and remembered.

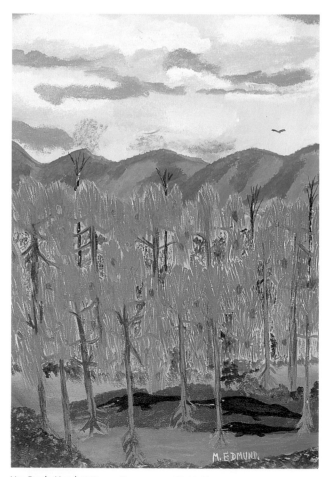

My Back Yard *1988 acrylic on paper 78 × 56 cm*

mabel edmund

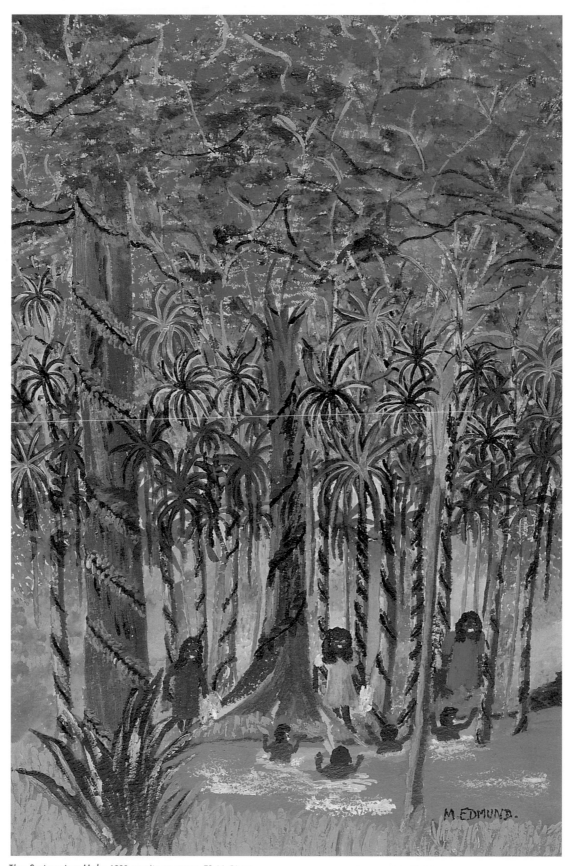

The Swimming Hole 1988 acrylic on paper 78 × 56 cm

Inside Looking Out 2 1988 acrylic on canvas 150 × 120 cm

trevor nickolls

Trevor Nickolls is an outstanding contemporary artist who has been painting and drawing for most of his life.

He attended art classes from the age of eight and began his Fine Art painting studies in 1967. Over the next two decades his work evolved dramatically both in style and content. There are contrasting themes of peacefulness and frustration, alienation and harmony pervading the dreamlike quality of his imagery.

After completing a Fine Arts Diploma at the South Australian School of Art, Nickolls trained further in South Australia and Canberra before becoming an art teacher. In 1980 he received a Post Graduate Diploma in Painting from the Victorian College of Arts, then took up a creative arts fellowship at the Australian National University. Following this he spent an important and formative period, while based in Darwin, travelling to outlying Aboriginal communities. He has maintained a full-time professional career as an artist for twenty years.

The major theme of his work is "Machinetime" and "Dreamtime" — man relating to both the cityscape and the landscape in the 20th century. The paintings reflect the polarisation of these themes in both a personal and a social sense. The artist's own internal evolution with his Aboriginal and European heritage, and his profound sense of loss of the warmth and depth of traditional Aboriginal society, is in contrast with the alienation and aggression he finds in industrialised urban life.

Trevor Nickolls was born in Port Adelaide in 1949 yet his first contact with traditional Aboriginal artists was not until thirty years later in 1979 when he met the Papunya painter Dinny Nolan who came and stayed with him in Melbourne. The artist has always pinpointed this meeting as a changing point. It gave him the vision of a truly Australian art drawn from both Aboriginal and western heritages. During this meeting he learned the approach and technique of the desert artists. In a more meaningful way, over time he also came to feel a part of the continuity of Aboriginal culture through Dinny Nolan's deep knowledge of the religious aspects of the landscape, and willingness to teach and share this. His paintings subsequently became more concerned with people as an integral part of the landscape.

The patterning and detail in these works incorporates the symbols derived from Central Australian Aboriginal art as well as the artist's imaginative, personal symbols that go beyond dots. In many he expresses trees, spinifex or shrubs through the simplest elements of pattern.

Nickolls has a strong sense of humour and the bizarre, incorporating absurd aspects of living in this day and age. At times when the internal struggle of Dreamtime-Machinetime becomes too intense, his anxiety emerges in his self-portraits. Recent works incorporate peaceful views of natural landforms overlayed with pattern and dot.

My painting is a marriage of Aboriginal culture and western culture to form a style called traditional contemporary — from Dreamtime to Machinetime.

One of the things I like is ironies. I try to work imagery in the painting, for instance, Ayers Rock symbolises knowledge.

Sometimes I work in a cycle when I do Dreamtime paintings, think about the way things were 200 years ago. Then I paint Machinetime which are political paintings of the city and society today.

It's good to return to the Northern Territory and feel the spirit of the Dreamtime. It just knocks me out the moment I get into this country, it wraps itself around you, full of spirit, the space, the Dreaming, imagining how it was once upon a time.

Childhood Dreaming 1973/4 oil on canvas 195 × 285 cm

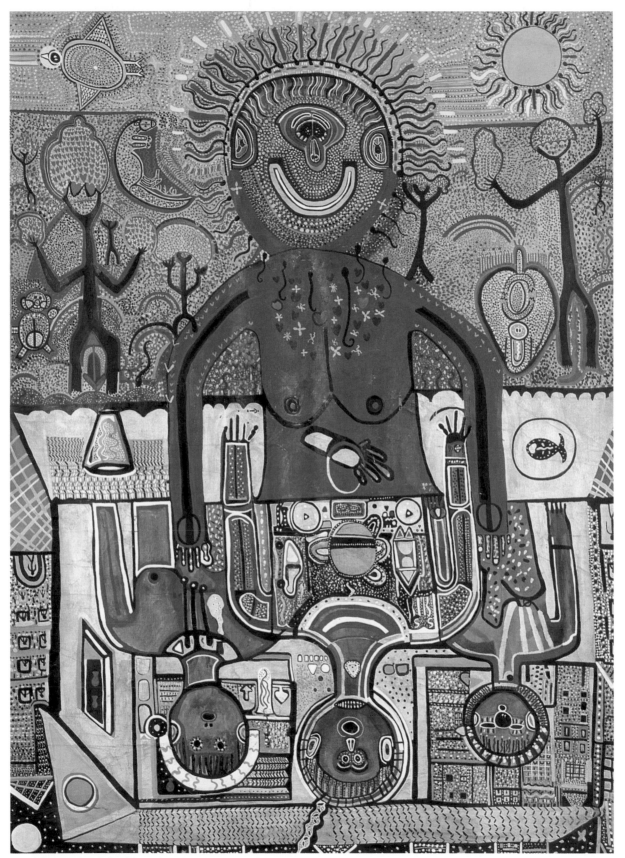

From Dreamtime 2 Machinetime 1979 oil on canvas 161 × 117 cm

In the Garden 1988 acrylic on canvas 91.5 × 76 cm

Centre Landscape 1988 acrylic on canvas 91 × 121.5 cm

Rainbow Serpent Before Entering the Waterhole 1986 oil and wax crayon on cotton paper 65 × 47 cm

jeffrey samuels

Jeffrey Samuels's paintings are intricately worked compositions with a linear complexity reminiscent of bark paintings, a central influence on his patterning technique. His distinctive "Australia" series of paintings with its images of the map of Australia are about reconstructing national heritage, the clearest icon being the map of the country.

Jeffrey Samuels was born in Bourke in 1956, but after his mother died he was brought up by white foster parents on a sheep property near Carinda in northwestern New South Wales. He completed his high school education in Grafton and then studied at the National Art School, Sydney, and later at the Alexander Mackie College of Advanced Education where he received a Diploma in Art in 1978. His further studies were completed in 1984 at the City Art Institute where he received a Bachelor of Arts (Visual Arts).

His early memories of the New South Wales outback are of travelling miles to school, catching the schoolbus at the property gate, his foster-father driving the schoolbus, and the irksome task of cleaning the bus at the end of the week. He pinpoints his earliest interest in art to tracing his shadow in the late afternoon sun on the side of the house. Later, he enthusiastically took up pencils, paper and paints which he had been given when recovering from a broken leg. He knew then he had to be an artist.

It was not until the late 70's that Jeffrey had an opportunity to learn about Aboriginal culture when the Woomera Aboriginal Dance Group from Mornington Island toured schools in New South Wales. He became absorbed.

After completing art studies, Samuels received a grant from the Aboriginal Arts Board to study traditional painting and culture on Mornington Island with the Lardil people. The time spent there has been a constant influence. Some of his paintings also have their source in the traditional beliefs and culture of the Lardil, particularly the religious explanations for the origin of the land, and the importance of the sea or its creatures. Tooartual, the Rainbow Serpent, and Djewarn, the Dolphin, are repeated subjects.

Jeffrey's "Australia" series and his dolphin paintings are often executed using decorative patterning combined with multiple images of the subject repeated across the surface.

Samuels has been exhibiting since the late 1970's. In 1980 he travelled to the Unitec

States and since then he has been consistently active in the development of urban Aboriginal art and the need to expose this work to a wider audience. He was one of the founding members of Boomalli Aboriginal Artists Ko-operative in Chippendale, Sydney, which held its first group show in 1987.

I painted the dolphins because everyone is killing them. They are such beautiful creatures and they should be saved. When I was on Mornington Island, Uncle told me that people gathered along the shore and hit the water with a stick whilst singing songs. The dolphins then came towards the sound driving the fish they were after before them. The dolphins were just fishing themselves and they would push them into shore close to where people could spear the fish and net them.

Australia Series #5 *1987 ink, gouache and oil on cotton paper 65 × 47 cm*

Dolphins 1987 painted canvas 203 × 117 cm

River Pictorial 1989 acrylic on canvas 40 × 50 cm

sally morgan

Sally Morgan was born in 1950 and lives in Perth. Recently she has become a very successful novelist as well as a prominent Aboriginal painter. Her book, *My Place*, describes her own family life in Perth, and the slow and painful prising from her mother and grandmother of the facts about their Aboriginal heritage.

In the course of researching her family history for the book Sally met Solomon Cocky, a relation who lived on the edge of the desert who, although nearly blind, spent his days drawing his stories on paper.

She was again inspired to try and realise her childhood dream to become a professional artist. She has been painting ever since. Many of her works deal with the history of Aboriginal people in Western Australia and are usually based on personal stories told to her by relatives and friends.

Sally Morgan has had no formal art training, but started drawing with pencil and paper as a child, and also experimented with oils and plaster of Paris given to her by neighbours. She had a passion for art; the only thing that interested her was drawing and painting and she paid little attention to her other school work. However, her early efforts met with her teachers' disdain and she felt so discouraged with painting that eventually she gave it up completely, burning all her earliest works.

Sally had not touched a brush or pen for about twenty years when she met Solomon Cocky who showed her his detailed pen and ink drawings of animals. In his work she saw striking reminders of the art she used to do herself.

Morgan then started to draw once more, realising that for twenty years she had suppressed this side of her nature — perhaps the subconscious "Aboriginality" of her visual expression. After much encouragement her works were first shown in Fremantle, Western Australia. Since then she has produced large works and limited edition prints which are exhibited nationally.

The artist uses small figurative pictures to build a "story". Her colours — bright and shocking blues and pinks with black outlines around all her "characters" — have little relationship to traditional "Aboriginal" ochre colours. There is, however, a spiritual link

and a deep concern for social issues. The bright colour, symmetry and circular formality of her work is occasionally reminiscent of other great contemplative religious art traditions — perhaps ancient patterns of ritual interlacement, mandalas or rose windows.

Many paintings are intensely personal, frequently reflecting issues that touch her own life — dispossession, lost children and the spiritual continuity between Aboriginal generations, past and present.

My paintings are either historically based, dealing with past injustices against Aboriginal people or communicating some aspects of Aboriginal culture. They are about the relationship between people and their physical environment.

Terra Nullus *1989 acrylic on canvas 180 × 150 cm*

Anxious Angels 1989 acrylic on canvas 75 × 50 cm

Hold on to the Dreaming 1989 acrylic on canvas 180 × 120 cm

Turtle and Lizard 1988 linocut on paper 39.2 × 31.7 cm

pooaraar

BEVAN HAYWARD

Pooaraar was born in 1939 in Gnowangerup, a small town in Western Australia, about 350 kilometres south of Perth. He was the fourth eldest of fourteen children and lived on the United Aborigines Mission.

After leaving school at fourteen he spent six years doing mainly seasonal farm work. His free spirit and the need to earn a living meant that over the next eighteen years he was to travel extensively as an itinerant labourer, working on properties in Albany, Esperance, Kalgoorlie, the wheat belt area in South Australia, Victoria, and New South Wales, and also further north in Queensland.

In 1977 Pooaraar returned to Perth where the growing developments in opportunities for Aboriginal people excited him. Determined to seize the chance to develop his capabilities, he completed an Aboriginal literacy course in Perth and, in 1979, a bridging course for access to the Western Australian Institute of Technology.

Pooaraar is an artist who can draw from numerous experiences to express the landscape in which he has travelled so widely.

In 1986 Pooaraar was accepted for the TAFE Aboriginal and Islander Art course in Cairns and there learnt screen-printing, batik, ceramics, painting, and drawing.

His talent was immediately apparent. He had a prodigious output, particularly of black-and-white linocuts, which mesmerised with their vibrating patterns and grids. Most of the work the artist completed in Cairns was based on the natural fauna that he knew from his bush experience — stingrays, barramundi, brolgas, goannas, and turkeys. In Cairns, however, his work was also influenced by visits the students made to the Laura Aboriginal rock art galleries.

On completion of the Cairns course Pooaraar moved to Canberra where he continued his professional art development in the print department of the Canberra School of Art. His linocuts reflect his preoccupation with evolving forms, the relationships between spirits and nature and the continuity of Aboriginal presence within the Australian landscape as a timeless phenomenon.

My prints are based on the spiritual side of Aboriginal life, the prevailing bushland spirits and features of rock art. This art depicts long extinct animals and birds and half-spirit/half-people, half-animal/half-people, half-spirit/half-animal, half-people/half-bird, half-spirit/half-bird entities.

They are a line of different atom structures starting from the ancestral atom structures (beings) through different stages of the evolving process of life. These changes were caused by the great upheavals of the earth over a very long period of time. Each different spirit tells about a period of one of these great upheavals of the earth until we finally come to the contemporary Aboriginal.

My aim is to show that Aboriginal people were never migrants and that they evolved in Australia and this is their rightful land.

Spirits of the Australian Bush 1988 linocut on paper 48.2 × 29.8 cm

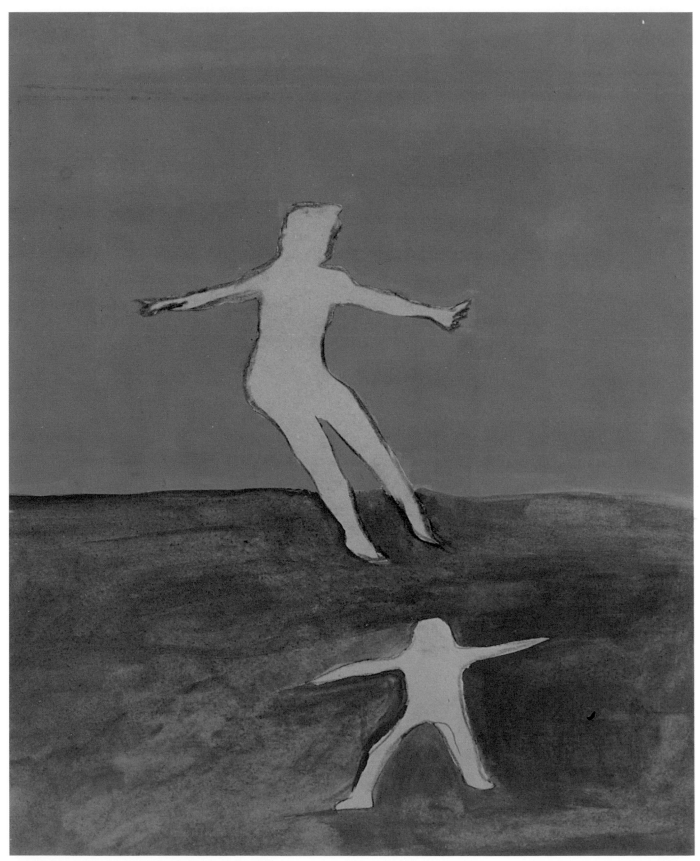

Denis Nueie and Biami Figure at Kuringai Chase, NSW 1985 acrylic and charcoal on paper 56 × 46 cm

avril quaill

Avril Quaill was born in Brisbane. Her people include members of the Noonuccal/Nuigi and Minjerriba people of Stradbroke Island.

After completing high school in Brisbane in 1975, Avril then travelled and in 1985 she completed a Bachelor of Visual Arts at the Sydney College of Arts. An extremely active, urban-based artist, Avril Quaill has previously worked on inner city murals and mosaics including projects at Central Railway Station, Sydney, Cleveland Street High School, Alexandria, and a large joint work in the form of a mural-painting at the Gold Coast Centre Gallery.

In 1986 Avril received an artist's grant for professional development from the Aboriginal Arts Board and travelled to Ramingining where she worked with other artists on a screen-printing workshop project, as well as assisting to manage the craft shop that supports the local traditional painters and sculptors.

Avril Quaill's designs have been used in many political formats. Her themes in these have included black deaths in custody, publicity for the Committee to Defend Black Rights, Aboriginal Education, a cover for the White Australia Invasion Diary and more recently commissioned graphic work for corporate clients. She has also worked with government departments involved with educating Aboriginal people on public health issues including AIDS, child abuse and sexual assault.

Quaill maintains she went to art school because "a friend of mine pointed out that all the best bands went to art school: The Rolling Stones, Talking Heads, Mental As Anything. I'm still a frustrated musician."

In her work the spiritual and political constantly intersect and overlap. The artist is a highly active and prominent member of the Boomalli Aboriginal Artists Ko-operative. When Avril was growing up in the sixties she observed that "if you were black all you could be was an activist" and mentions Dennis Walker (also Noonuccal) and Roberta Sykes from Queensland. She herself also has a message and a mission but expresses this through her art; she wants to change things, but also, she *likes* to paint. To Avril Quaill, art is an important mechanism for interaction with other Aboriginal people; it's also a means of

educating the wider community on past injustices while suggesting ways of approaching the future with a positive viewpoint.

In one of her works, the silk-screen "Trespassers Keep Out!" she links obvious images of the Aboriginal flag with more subtle notions — the exclusion of Aboriginal people from the white ideal of the English cottage home and flower garden with picket fence. The garden and flowers in this work have a distinct feminine approach albeit with references to fringe dweller dispossession and Aboriginal outsiders in suburbia.

Quaill feels art has not necessarily replaced activism but it is a subtle and enjoyable way of communicating and expressing her feelings as an Aboriginal in contemporary Australia.

I would like to change a few things through my art. I also like to paint. I've accepted the reason I do it is because, like music, it is just something that I do. Nobody taught me to paint, I never went to drawing classes at college. I never had a formal painting lesson in the technical sense. There was too much else going on at college — discussion groups, visiting artists, the Bienniale, although I resented being the only Aboriginal in my year. I met Fiona Foley when she was in her second year and I was in my third. We were the only two Murris in the art college. We didn't get to know each other until I got my artist's grant and joined her in Ramingining, and then afterwards when we started Boomalli; we came from all over the country, but for one reason or another we all live in Sydney. We saw a need to work together as a group to promote urban Aboriginal artists and their work, as well as keeping in contact with the other artists from the country and the bush.

I found during my years at art school I was constantly looking for support and contact from my own people and especially other Aboriginal artists. At that time there was not much — the Aboriginal Arts Board seemed to have few resources available to a Koori art student. The staff at the time didn't seem to have much knowledge of the fine art movement. I often found myself being put on the spot to answer questions for my people pertaining to Aboriginal art and Aboriginal perspectives on Australian art movements — questions about such issues as appropriation of images by Australian/European artists, urban Aboriginal art or copyright.

There are a lot of organisations which deal with Aboriginal art but unfortunately these organisations are not run by Aboriginal people.

Most of the Boomalli membership has been through the same experience in art institutions. Here we can redress this imbalance and develop as a resource to future students in giving Aboriginal views on shifts in the wider art movement.

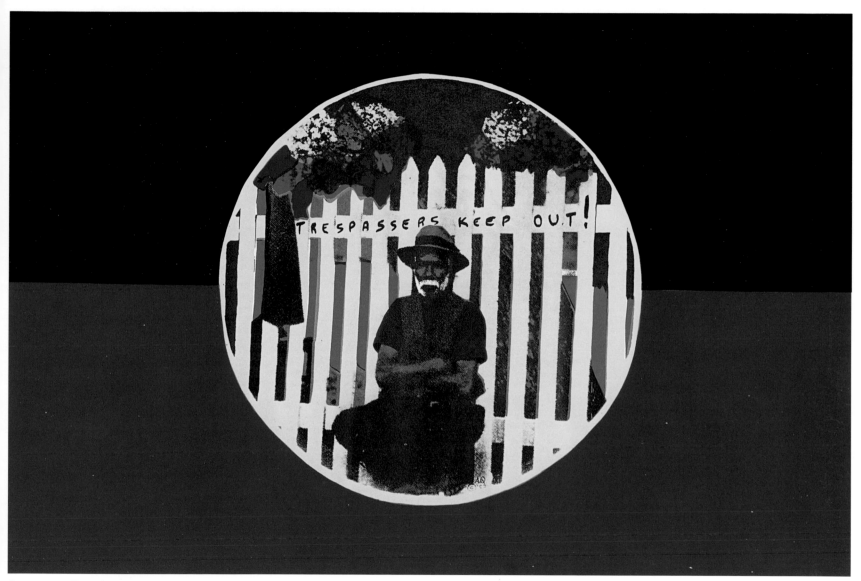

Trespassers Keep Out! 1982 silk screen 72 × 84 cm

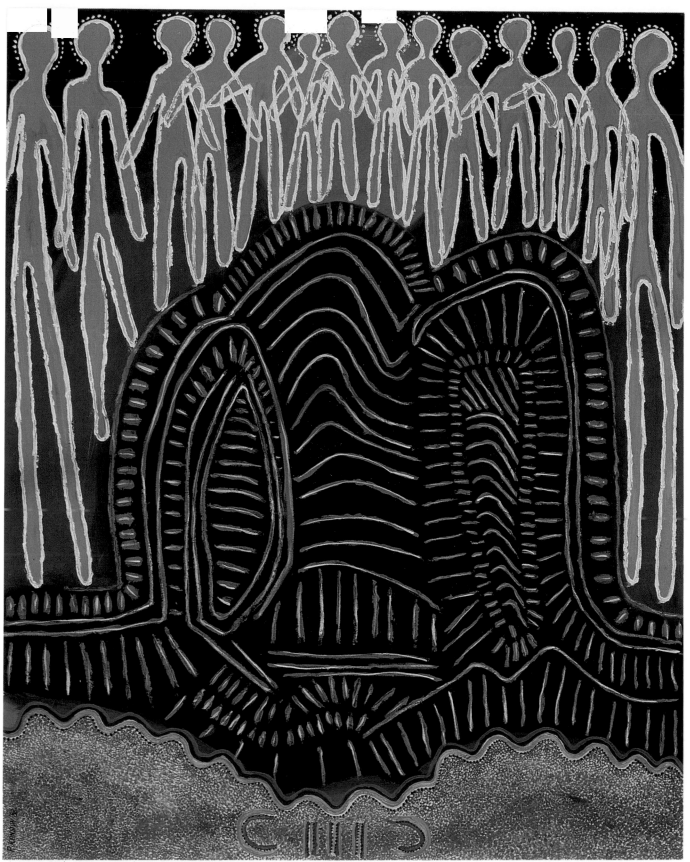

January 26th 1988 — **We have Survived** 1988 oil on canvas 150 × 120 cm

pamela johnston

Pamela Johnston, a descendant of the Gamileroi people of the Moree-Tamworth area, lives and works in the heart of the inner city in Woolloomooloo. She completed a Higher Certificate of Art at East Sydney Technical College in 1987.

Her main exhibitions have been in the area of community women's art. She has worked on murals at women's refuges in Tempe, Sydney and at Bidwell, New South Wales, and in 1986 was a founding member of Kelly Street Kolektiv Gallery, a democratic artists' space with a broad community access philosophy. She has exhibited in a number of women's art shows including the Cell Block Theatre, Bondi Pavilion, and in 1988 "Unearthing the Goddess", a selected women's show on the pervading historical theme of the female goddess. This latter exhibition was held at the Kelly Street Kolektiv.

Pamela Johnston's past involvements have formed a background to the concerns in her painting. From 1979 to 1986 she worked with services for women in crisis: refuges, health information services, rape crisis centres, and women's councils on homelessness and addiction. She has initiated and established Aboriginal support groups in women's refuges and has worked consistently as an organiser with the Marrickville Women's Refuge in Sydney.

The bicentennial year fused her concern with women and with the future of Aboriginal people and she participated in central exhibitions of protest including "One land, One people, One law" at the Balmain Loft Gallery and the anti-bicentennial exhibition at the Kelly Street Kolektiv Gallery, Ultimo, New South Wales.

Although her exhibitions and activities are largely urban, her themes are far from this. Her paintings concern the broader spiritual basis of women's creativity throughout time — from the theme of the great goddess of the bronze age to the linked perceptions of female power and creative force in Aboriginal religion.

Pamela spent some time in the Kimberleys working with traditional Aboriginal women as well as in Kalgoorlie and Mt Isa.

Using mostly acrylic or oil on canvas and occasionally pastel pencil on paper, Johnston often depicts central images of iconic Aboriginal female creative ancestors from traditional Aboriginal painting. Some of her best known works concern female creative ancestors of

western Arnhem Land — among the Gunwinggu known as *Ngalkunburiyaymi*. The image of this, produced here in "Woman Spirit and Me", is overlaid with other references. The creative sexual posturing, the ritual regalia and the strong black footsteps all suggest other interpretations, the original female creative act that ultimately produced the true Aboriginal community. Aboriginal people here are represented as soft, hazy spirits in the upper surface of the picture.

Pamela Johnston's work is increasing in recognition. Her important exhibition in the bicentennial year at Boomalli Aboriginal Artists Ko-operative Gallery, Sydney, confirmed the talent shown when she won the Lucien Mochalski Bequest for painting in 1987.

Johnston's views on the historical place and role of women in Aboriginal art and the central importance of communication and connection between women continue to inform and affect her painting. In presenting women through visual symbols and reference as powerful and creative constants in the history of the Aboriginal struggle, her paintings continually stress women's roles politically and spiritually.

I'm trying to live our culture by celebrating it through image. Particularly, what is anybody? We know who we are by birth and by culture. Our culture confirms that we exist through ritual, image and spirituality. It is us and our lives confirm it.

I try and celebrate the continuous growth of our spiritual existence through the images I use. This way I continue to affirm and increase our connections to our ancestors and our land and to each other. I also seek to connect broader images of spirituality, particularly those of women.

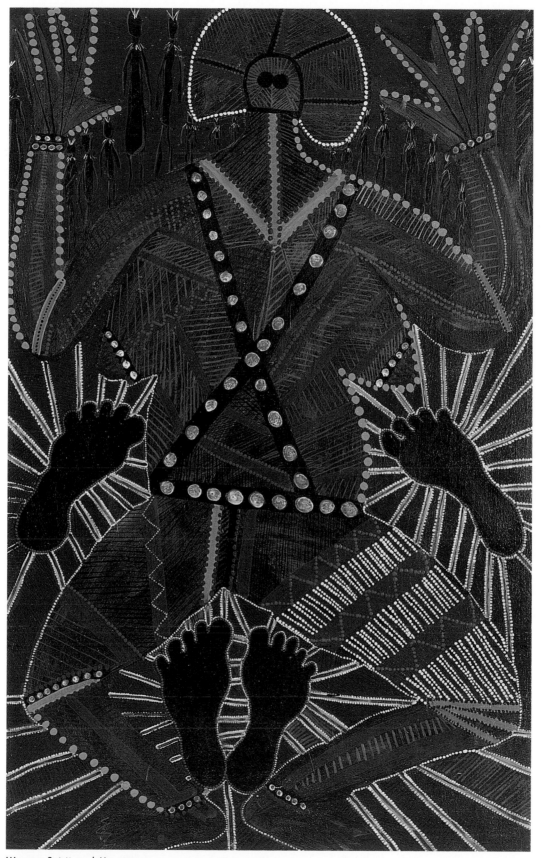

Woman Spirit and Me 1988 acrylic on canvas 118.5 × 75.5 cm

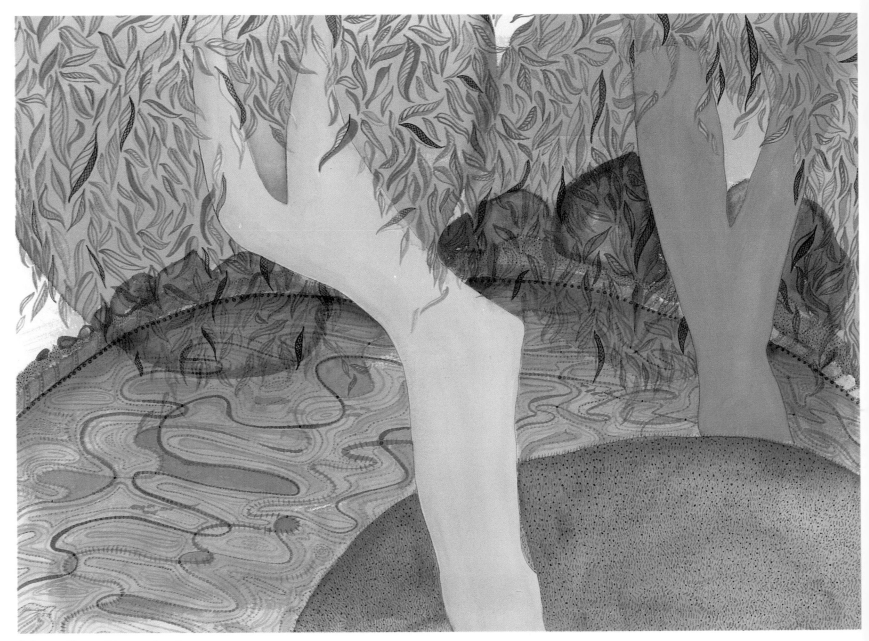

A Bay up Home 1989 watercolour 75 × 116 cm

ellen josé

Ellen José was born in Cairns, North Queensland, the eldest of six children. Her work reflects her ancestry as well as an interest in fusing Asian and European techniques and media with Torres Strait Island and Aboriginal patterning, techniques and symbols. She has adapted this to create her own unique painting style.

Ellen left school at fifteen and worked at various jobs including ticket writer, window dresser and, later, lay-out work, the job that was to prove a grounding for her career today as an artist and photographer. She gained a certificate in Applied Art in Brisbane, a Diploma of Fine Art from the Preston Institute of Technology in Melbourne, and a Diploma in Education (secondary) from the Melbourne State College.

While bringing up four children, Ellen José now works professionally as a painter and photographer and is represented in major Australian collections.

The "Aboriginal" influences in this artist's work are felt rather than visually described. In the catalogue to her first joint exhibition in 1986 she suggests some of the forces behind her imagery: "No matter how dull or uninteresting the landscapes may appear to some of us there is life and colour and space of boundless beauty. Lines, circles and oval shapes tell us of a world and its shape and we are part of it."

Many paintings express love of the country around her birth place; they have also been a way of coping and coming to terms with personal loss.

In a solo exhibition of watercolours in 1987 Ellen speaks of trying to open windows on the landscape and of crossing cultures, distance and time.

In Ellen José's work, simple lines, arcs and patterns evoke vegetation, rivers, mountains, and wildlife from the islands to the sea. At times empty space can be as eloquent as the textured area of pattern and symbol.

In 1980 and 1981 Ellen José worked with the Victorian Aboriginal Education Service and as a high school teacher. She travelled extensively first in 1980 to Japan, then to India, Egypt and Europe in 1982, absorbing and observing colour, life, landscape and patterns of other cultural traditions. Her work is best described as an attempt at "fusion", a word she frequently uses herself. Her gentle watercolours contrast with her strong black-and-white

linocuts and her powerful black-and-white photographs.

In common with many women artists who are also busy mothers the artist does all her painting on her kitchen table.

Over the last ten years her love of travel has taken her to Vanuatu, New Caledonia, Japan, Europe, India, and China. The visit to China was the catalyst for the calligraphic content of many recent works.

Although her art is predominantly gentle, even feminine, and evokes the spiritual qualities of the Australian landscape, her photography wields a harsher weapon and, in a recent exhibition, stark images showed communities of Aborigines living in dire poverty at Dareton and Fletcher's Lake near Mildura in Victoria.

My work is a fusion of cultural techniques, design and patterning, emphasising the fact that all people can maintain their own distinct and separate cultures, while living together in peace, understanding and harmony, in a very shrinking global village. Mutual respect for different cultures can occur by an understanding of each other's cultures through art, dance, language, and music.

Sea Scape 1987 *linocut on ricepaper* 15 × 15 cm

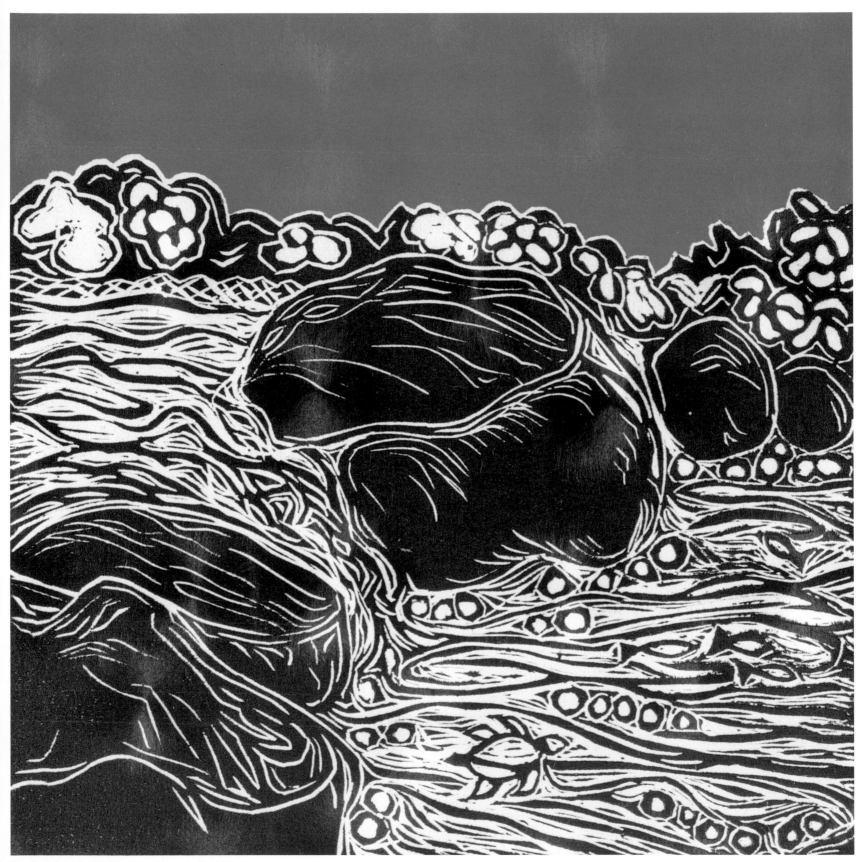

The Boulders II 1988 linocut on ricepaper 15 × 15 cm

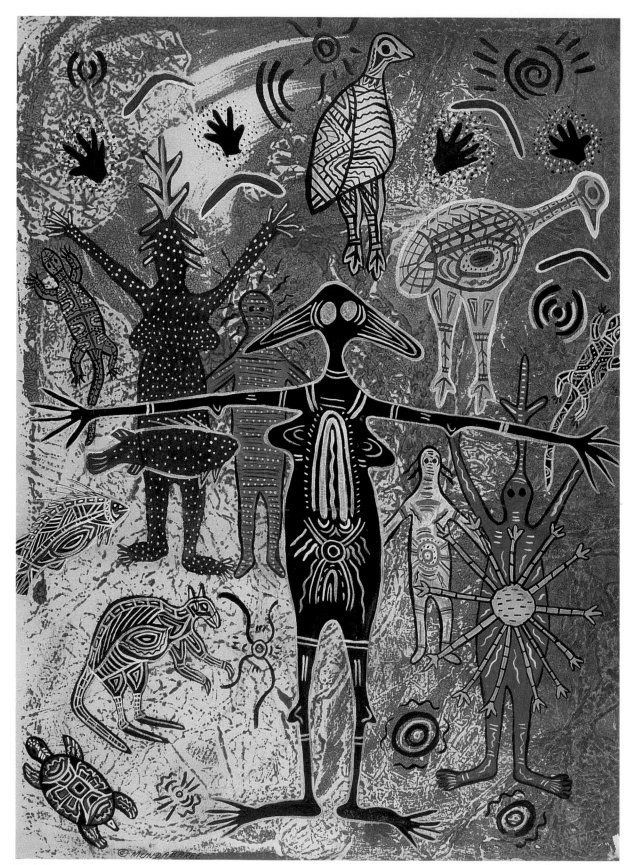

Myth Figures 1988 mixed media 56 × 38 cm

mundabaree

JENNIFER GREEN

Mundabaree was born in Mareeba, North Queensland, but grew up with her parents at Mona Mona Mission near Kuranda, west of Cairns.

Mundabaree's father, a member of the Idinji-Tjapaki people, was born at Kairi on the tablelands; her mother was born at Mareeba. According to Mundabaree her parents were moved to Mona Mona when young because it was government policy of the day to transfer families to different missions. Her father went to Mona Mona when small she says "for putting a stone on a railway line". Her mother's father was from Cooktown although he lived and died at Mona Mona. Mundabaree draws some of her skill and imagery from him as he was a direct descendant of the ancient cave painters of the Laura-Cooktown area. Mundabaree now continues to paint images of the animals and bush creatures that can be seen in the rock art friezes.

Mundabaree completed Year 9 at Kuranda State School. Here she painted realistic landscapes of trees, mountains and rainforests. She also remembers she liked to sit at home drawing pencil designs of flowers, or making feather flowers. She learnt this traditional Aboriginal women's art from her mother. When young, Mundabaree also worked with her father painting shields and boomerangs carved by Ron Richards. The images were the traditional creatures of the environment and bush tucker animals — snakes, goannas and turtles.

Mundabaree received her Aboriginal name from her grandmother at birth, but her family also gave her the name of Jennifer Green, which she used throughout her schooling, reclaiming her Aboriginal name when she attended the Cairns TAFE Aboriginal and Islander Art course.

Mundabaree paints on her kitchen table in Kuranda, sitting up late after her boys have gone to sleep. Electricity was connected only recently. Before this, she would often paint by candlelight using the traditional colours, but mixing reds, yellows and whites to get the unusual combinations and colours she likes.

The artist's work is often filled with pattern and design. She observes nature in a detailed contemplative way. "I see certain shapes and things around me. Sometimes I see

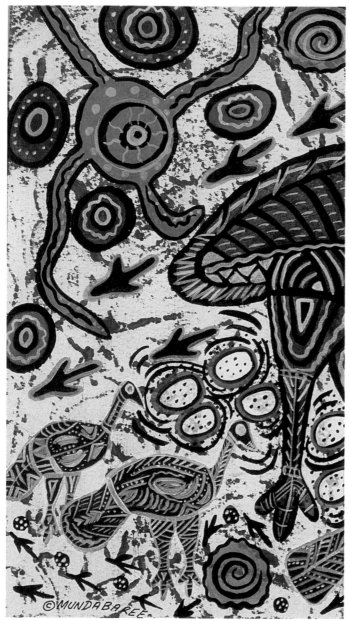
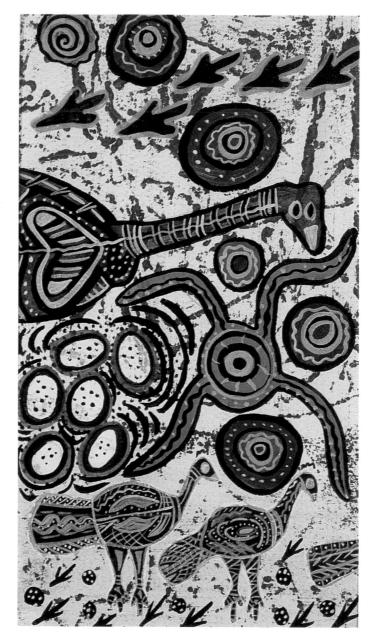

Birds Gathering (diptych) 1988 mixed media 33 × 27 cm

a little pattern on a beetle or a lizard or on a snake's skin and I change this or remember this when I paint. Sometimes I do sketches of patterns from trees. This was in me all the time but when I was doing my course it all came out.''

My art depicts the stories passed down by my ancestors and the paintings are my imaginative impressions of the meanings of the stories told to me of the Rainforest and Northern people.

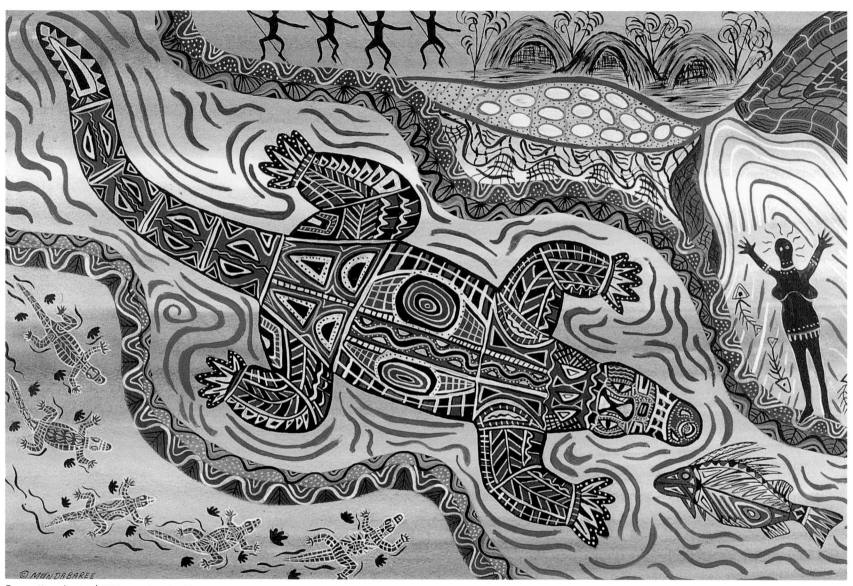

Dreamtime Legend *1988 mixed media 38 × 56 cm*

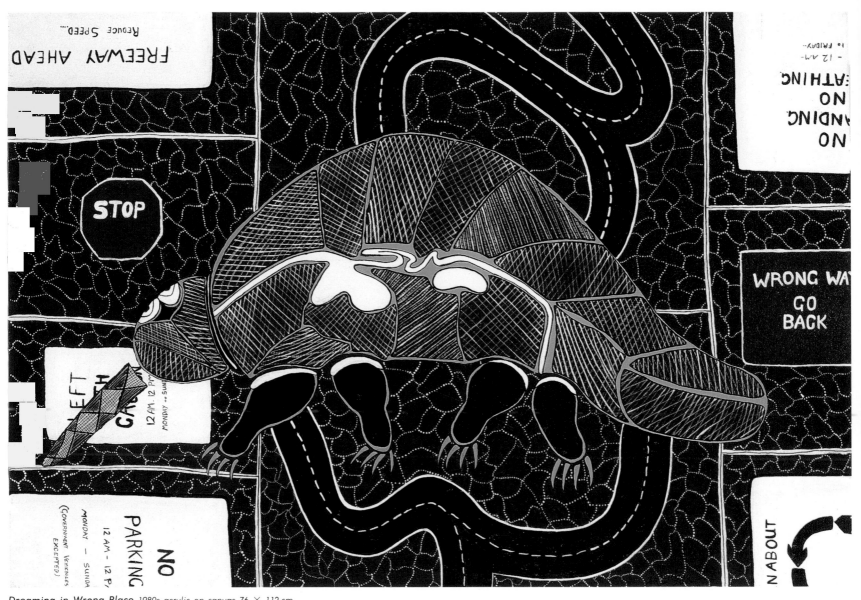

Dreaming in Wrong Place 1980s acrylic on canvas 76 × 112 cm

leslie griggs

Leslie Griggs was born in Melbourne. The traditional lands of his people, the Gournditj-Mard, extended from the Grampians to the sea near Portland. Lake Condah Mission, where his mother was born, was closed when Les Griggs was only two. At that time he and his brother were taken into care under the Aboriginal Children's Act, thus beginning twenty years of life in institutions. Children's remand centres were followed by virtually continuous stretches in gaol.

Leslie Griggs maintains that, in a personal sense, his Aboriginality in institutions was positive, although he was very isolated. His brother, the only other Koori, was separated from him at the age of ten and sent to another institution. From then on he felt his Aboriginality created a negative reaction around him — "Like being a leper in a health institution".

He learnt to paint in gaol and is largely self-taught, although he was inspired by visits from Aboriginal artists — in particular a Pitjantjatjara man who talked of traditions, land, dreaming, and art. Lin Onus has been another important mentor.

The artist paints in his house at Northcote, in inner city Melbourne. "I paint out of my head — I just sit in front of the canvas. I love the spring of it." Most of the works are, in his words "against the system". The themes are of alienated Aboriginal society, people under stress. They are often confronting, always political. "I find it's the best way to get back at the system without leaving myself open to prosecution."

Images of addiction, hangman's nooses, handcuffs, and coded messages associated with drug use are clear in the works. One important painting, "Dreaming in Wrong Place", has its source in the distress the artist felt at seeing so many wild native animals lying killed beside the highways in the Australian countryside. "Animals can't read. To make people aware the Main Roads people put up these signs that animals can't read. There are other hidden messages too. The signs don't really say what you think they say. For example, 'Reduce Speed Freeway Ahead', relates to the use of drugs in gaols."

Some white viewers may find Griggs's work an uneasy combination of urban antagonism set against traditional Aboriginal patterning and symbols. But the artist maintains he

is "making an A B C out of Aboriginal art so that people can understand and read it next time. It is not intended to be frightening; it's just the way things are. The only way of making people understand is by putting issues in front of them."

The powerful messages that Leslie Griggs communicates through his paintings have been used in a number of Aboriginal campaigns for better health and conditions, in particular, a recent campaign to reduce Aboriginal diabetes. He has been involved in several community art projects and murals and was a delegate to the 5th Pacific Arts Festival in Townsville in 1988.

In my painting I try to relate the current issues that affect urban Aboriginal people such as drugs, alcohol, institutionalisation, deaths in custody, and land rights.

I use symbols that are readily identifiable to non-Aboriginal people so that they can relate to and understand the content of my work and learn that Aboriginal art is more than just decoration.

Night Time Dreamtime *1980s acrylic on canvas 100 × 150 cm*

Deaths in Custody 1988 acrylic on canvas 56 × 71 cm

Waterhole 1985 linocut on paper 30 × 28 cm

euphemia bostock

Euphemia Bostock was born at Tweed Heads on the far north coast of New South Wales, the second eldest of five children, and the only girl.

On her mother's side she is descended from the Bundjulung people of the Grafton-Lismore area; her father is from the Munanjali people whose tribal lands cover the area near Beaudesert, south of Brisbane.

In the early sixties Euphemia came to Sydney seeking work. She was self-supporting with two children. She recalls "I remember opening a paper in the morning and by 11 a.m. that day I was working in a handbag factory." Following this, her mother and father also travelled to Sydney where the family became active members of the Aboriginal community.

The Bostock family lived in Glebe in the sixties and seventies where, says Phemie, "Tranby and the Aboriginal Progressive Association was up the road, and the other active organisations at the time were FCAATSI Fellowship, Kirinari and La Perouse group. After this came the Foundation for Aboriginals in the city." The family was involved in setting up the Aboriginal Legal Service, and the Aboriginal Medical Service. Euphemia later concentrated on the development of theatre and the visual arts.

The earliest aesthetic influence that Euphemia remembers is her father's love of nature and the environment. She recalls him drawing the children's attention to beautiful sunsets or scenery. "Art grew on me gradually. I was probably influenced by many people I met in Glebe, like Thancoupie. Charlie French also encouraged me a great deal. The seventies were a very creative time and we all helped each other. I was one of the founding members of Sydney's Black Theatre, in Redfern. It was from the Black Theatre that the Aboriginal Dance Theatre originated."

Now a grandmother, Phemie's art is mainly focused on fabric, printmaking and sculpture. As the children grew up she found more time to move from the performing arts to the visual arts and attended part-time art courses. Sculpture is her main love and an important influence on her two-dimensional visual works. Her main early sculptures were of soapstone. She combines this with modelling in clay and cement casting. "I never have

a preset idea when I work with stone. I look at it, my hands feel the stone, then I stand back and see the direction I will take. With clay and casting it's different. I work with an idea in mind of the things I see in life."

Euphemia prefers natural materials and loves the texture and surface possibilities of handmade paper. The linocut prints are made on rice paper which gives a sympathetic and responsive surface to Euphemia's technique of using ink wash on the background behind the black print. Her fabric designs, sculpture and linocuts are all integrated. The physical carving of lino, for example, relates to sculpture, and the ink-washing of paper relates to fabric dyeing.

Euphemia Bostock was one of the founding members of the Boomalli Aboriginal Artists Ko-operative and is the oldest mentor in the group. Her experience of life and political struggle have formed a solid foundation for the group's stability.

I have worked in many forms of mixed media art and have been involved in many levels of artistic practice and now I am purposefully trying to move in different directions with unique graphic urban Aboriginal images.

Spirit Man 1985 silkscreen 30 × 32 cm

Trick or Treaty 1988 oil on paper 67 × 48 cm

fernanda martins

Fernanda Martins was brought up in Sydney by her mother and grandmother. They lived in the inner city suburb of Paddington in the early 1960s, before the area became elegant and fashionable.

Fernanda speaks of the isolation she felt as an Aboriginal in the city. Art has changed her life in a dramatic way and she has become part of a wide Koori art community. She speaks of "being a full person now".

Fernanda's grandmother, Margaret Anne Wallace, is a remarkable woman. She came originally from Boonoo Boonoo Station near Tenterfield in northwestern New South Wales and brought Fernanda up with stories of her life as a domestic servant and farm labourer in the bush. She also worked exceptionally hard on railway camps, constructing shacks for the itinerant railwaymen, slaughtering animals for their food, and cooking their meals. There was a strong and resilient side to her grandmother's influential nature, but there was also the gentle, storytelling, creative woman who embroidered and crocheted and encouraged Fernanda, her young grand-daughter, in her drawing.

In the early 1960's Liverpool Street was frequented by artists who drew the rows of crumbling, lacey, Paddington terraces. It was a period of tremendous artistic growth.

Galleries sprang up along the lanes and sidestreets of the suburb that Fernanda called home. Her own street was inhabited with a strange, new type of person; and as a child, Fernanda recalls, she would often wander into galleries to look with interest at what was on the walls.

During this time, Aboriginality was not something that urban Koories could be publicly proud of — it was an era of overt racism, of abuse in the streets. Whenever she was emotionally hurt Fernanda would retreat into her own world, making her own language in line drawings of contoured figures. Sometimes, when she felt angry, she would openly make graffiti. At home her drawings were more like private stories about feelings, people or incidents. At seventeen she travelled widely throughout Australia and overseas, visiting relatives, exploring life.

Her first formal art training was in South Australia where she received a Bachelor of

Arts in Fine Arts. She continued her art studies in Sydney at East Sydney Technical College, followed by a Graduate Diploma in Art Education from the Sydney College of Advanced Education.

Martins is one of the founding members of Boomalli Aboriginal Artists Ko-operative. Her work is technically highly competent. In 1976 she was assistant to the printmaker Charles Bannon, and her remarkably extensive work in the general arts community includes murals for Circus Oz and poster designs for Sidetrack Theatre Company, Sydney. Her first one-woman show was ''Up the Pub'' at the Experimental Art Foundation in Adelaide at the age of nineteen. She has since been widely represented in group shows in South Australia and New South Wales.

The artist finds in the solidarity of the artists at Boomalli, a firm and unifying focus for showing her work. Her own paintings have a dreamlike quality of reverie and reminiscence as well as strong presence of the Australian bush. One important work, ''Trick or Treaty'' was used as a poster by the Central and Northern Land Councils in 1988. Here the spirits which speak from past generations are present in the bush. A carved and ritually-marked tree stands as a totemic communicator to future generations. In the foreground a curlew seems to threaten a small shoot which, bathed in sharp sunlight, suggests new life, the resurgence of tradition and cultural strength among contemporary Koories.

How I paint is what I see in nature.

All Just Waiting 1988 pastel 77 × 107 cm

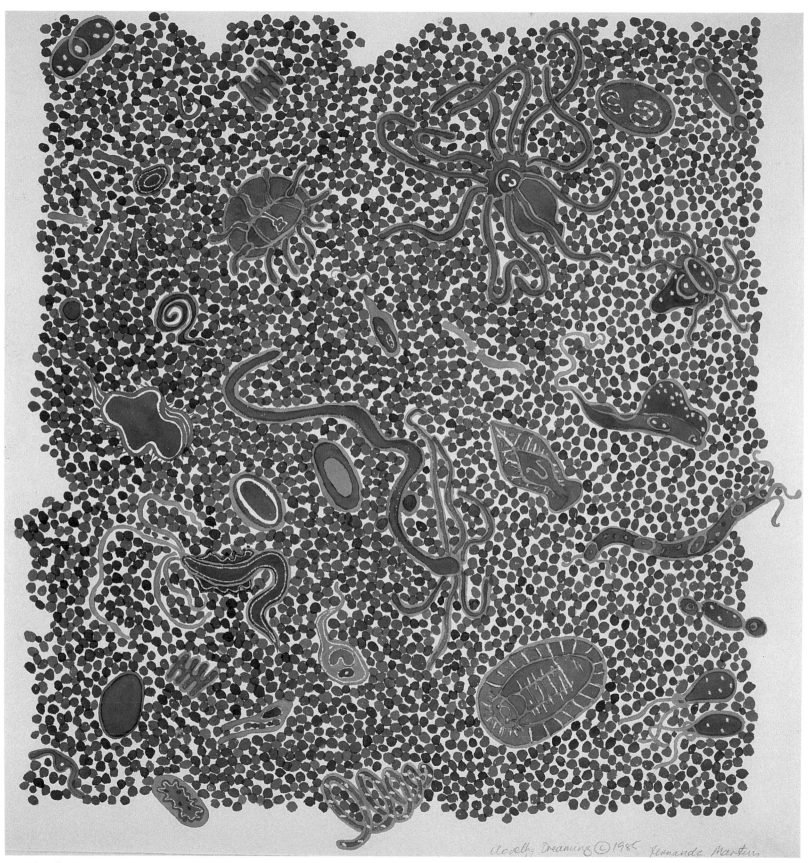

Clovelly Dreaming 1988 watercolour 61 × 57 cm

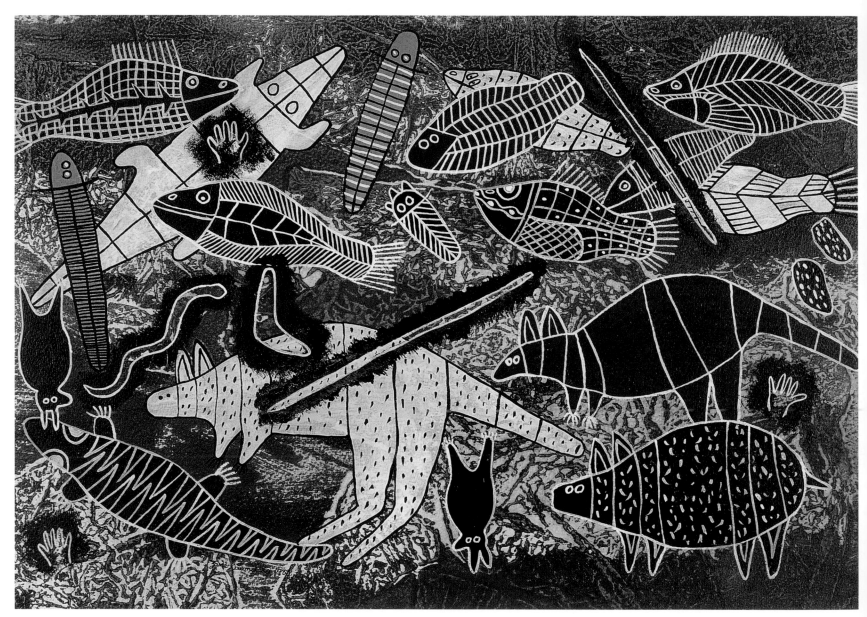

Stencil Rock Art Figures 1988 acrylic on paper 56 × 76 cm

zane saunders

Zane Saunders was brought up in the town of Kuranda, in North Queensland. His images reflect his traditional lifestyle: hunting wild animals, pigs, birds, and flying foxes, and fishing in the Barron River.

After going to school in Kuranda, Zane spent his final year in Townsville where he completed 10th Grade. When only fifteen years of age he joined the Abroiginal and Islander Art Course in Cairns. His mother's parents were from the Butchulla people of Fraser Island, a community that was dispersed and devastated during the colonial era. "Once in a while Mum talks about that. They had to move and Mum was brought up in Bundaberg."

His grandfather and mother brought the family to Kuranda where Zane, his two sisters and three brothers enjoyed the rainforest and all its foods. Even today he spends a great deal of time in the forest gathering earth worms and grubs for bait, or diving and fishing in the Barron River. Sometimes he fishes at night with handmade bamboo spears, using a torch. Most of his paintings are inspired from incidents on these bush journeys. "One day I was fishing when I saw a school of fish swimming both ways; it turned into my rainbow fish design."

Saunders's images come from what he calls "dream stories", incidents of everyday life which he transposes into images and cautionary tales in the true fashion of traditional storytelling. In one of these he is walking with his nephew and a friend in the bush when they find a "Black boy" bush with the stem shaped like a snake, the top was like a snake's head. They cut off the stem and took it back to frighten their friends.

All that day in the bush they kept seeing snakes wherever they walked, which frightened them. In the late afternoon they disturbed two snakes, which were mating, and one of the snakes attacked them in its anger. Zane's friend hit it on the head and they ran to safety. When they stopped they found that the head of the Black boy stem had broken off. Zane is sure the Black boy stem had been a warning to look out for snakes. "It was like a spirit thing." He painted a picture about this.

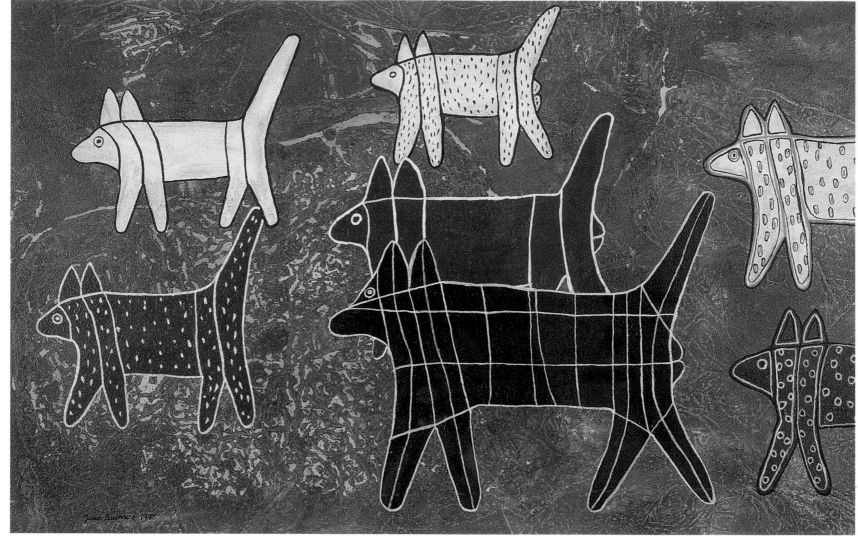

Dingoes 1988 acrylic on paper 56 × 76 cm

For a while the youngest in the group at college, Zane Saunders has nevertheless earned a wide audience. He recently completed a "rock painting" frieze in the Stockman's Hall of Fame at Longreach in Queensland.

I get all my ideas from my mind. When I go camping I see things like wild dingoes. One day I saw a whole pack of them on the sandbank of the Barron River. I just had a thought then that I wanted to paint dingoes roaming in the rainforest.

I'm always trying to get more ideas and ways of expression — trying for the bigger work.

124

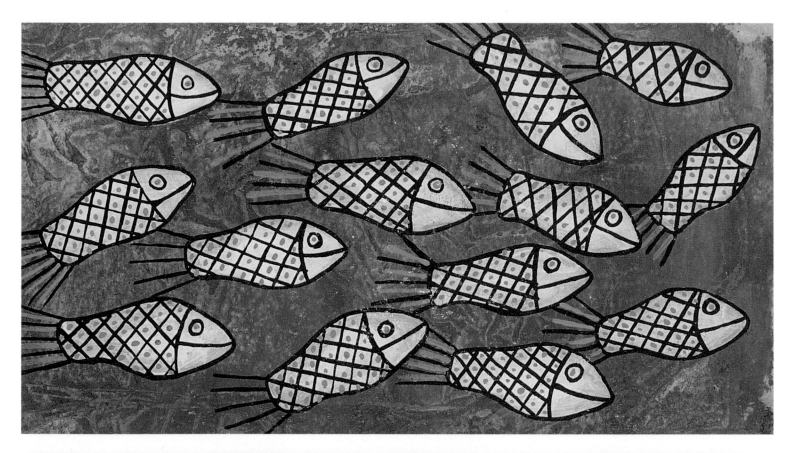

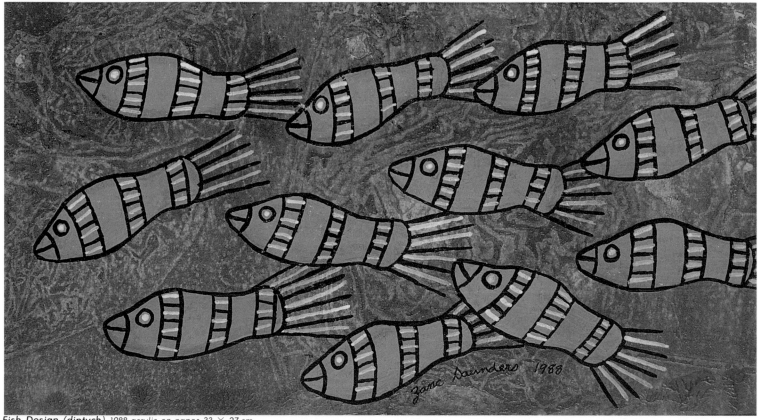

Fish Design (diptych) 1988 acrylic on paper 33 × 27 cm

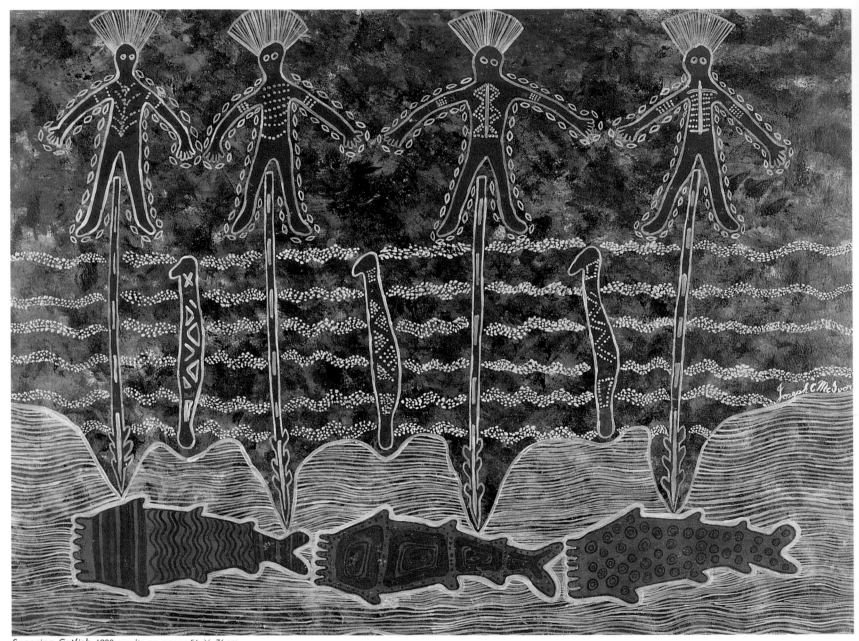

Spearing Catfish 1988 acrylic on paper 56 × 76 cm

joseph mcivor

Joseph McIvor is a young artist in his second year of the TAFE Aboriginal and Islander Vocational Arts Diploma course in Cairns. He was brought up by his grandparents in Cooktown. His family is from the Guuyimidhirr tribe whose traditional lands extend into the Cooktown and Hopevale area. It is natural therefore that his imagery reflects similar themes to those found in the familiar spirits, animals and fish of the rock art of the region.

Joseph went to Cooktown State School until he was about fifteen, and then moved to Cairns where he stayed with a white family and went to the Trinity Anglican School for two years. After completing Grade 10 he entered the TAFE art school where his first teachers included Anna Eglitis, Anne and Ian Horne, who taught batik, and Sheila Sparke who taught screen-printing. Joseph McIvor recalls that as a young child living a semi–traditional life, hunting, eating bush foods, and, in particular, fishing, he was not concerned with what was happening in what he calls "the other world". "At college I wanted to say something about it though. I felt proud and began to think about land rights."

Although he is a newcomer in the contemporary art world, his early work is strong and vibrant with a determined expression of his Aboriginality. In his painting of the Endeavour River, Cooktown, the river and its banks abound with all manner of bush-food. "When I painted that I was thinking about food — the Aboriginal people would not go far from food and I've eaten all those meats, fish and vegetables that are there." In another work, "Spearing Catfish", four hunters are shown with woomeras, spears and catfish. "Every flood there's a little lagoon that overflows and we always see these freshwater fish so we got them and ate them. There were over twenty. After that I painted this picture."

For young artists, such as McIvor, art is a new "way through". He speaks dispassionately about other boys his age who have nothing to do and who get into trouble with police. Joseph will shortly return to Cooktown where he will set up a screen-printing workshop attached to the Gungarde Community office. He sees his future in teaching, handing on his skills within the Aboriginal community.

The artist's images are directly related, through his cultural heritage to the paintings of the Quinkan-Laura area. He once visited the cave paintings with an old local Aboriginal

man. He was told that, in the past, Aboriginal people from Bloomfield, Mossman, Laura, and Cooktown all "put a bit of their own paintings there." After studying the paintings carefully he found a way to express the daily events of his own life using a symbolic language that had a direct cultural continuation with his ancestors.

At college I felt proud and wanted to bring out myself, as an Aboriginal. My family is glad I am at college. I'd like to teach Aboriginal Art because I did it at Mount Garnet, and the locals liked it. I like talking to the students. It brought me closer to them and I made good friends. Every Aboriginal has something to say about today's conditions. I think the most important thing is land for the people . . . and jobs.

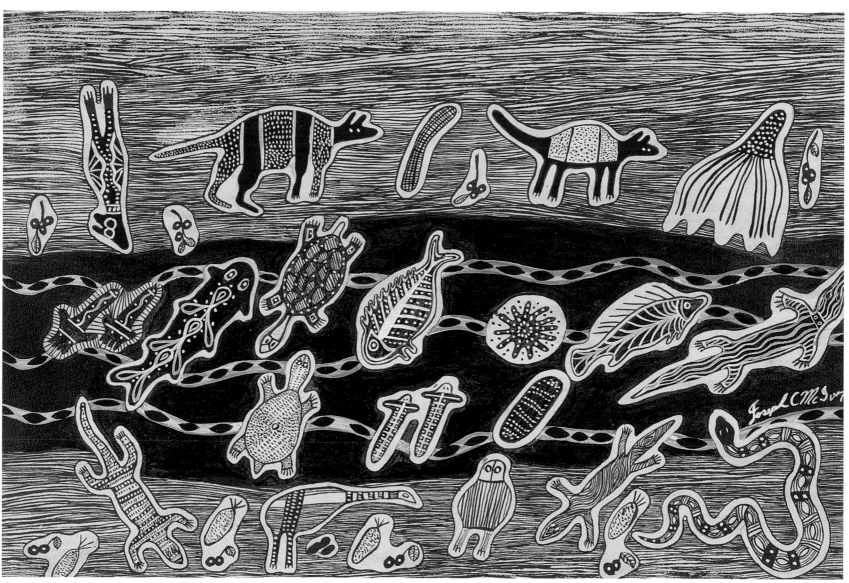

Aboriginal Food 1988 acrylic on paper 38 × 56 cm

BIOGRAPHICAL DETAILS

Artists are listed in alphabetical order.

BRONWYN BANCROFT

Born: 1958, Tenterfield
Studies: Diploma Visual Arts, Canberra School of Arts, 1980
Grants: Aboriginal Arts Board Grant, 1983 and 1985
Exhibitions: Group: Diploma Exhibition, Canberra School of Art 1979; Graduate Diploma Exhibition, Canberra College of Art Photographic Works, 1980; Fashion Parade, Canberra, 1982; Fashion Parades, Sydney, Melbourne, 1986; Fashion Parades, Paris, Sydney, Canberra, 1987; Fashion Parades, Sydney, Armidale, Kyogle, 1988; "De Facto Apartheid", Boomalli Exhibition, Performance Space, Sydney, 1988; "Tin Sheds", Boomalli Exhibition, 1988; Victoria and Albert Museum, London, "The Contemporary Art of Dress"; ABC Australian Craft Series, 1989
Commissions: Human Rights Poster 1979; Aboriginal Medical Service, Townsville Uniforms 1983; Australian National Museum, handpainted garments 1985 and 1987; Australian Jazz Society poster; Australian Museum, handpainted ensemble 1988; Oroton scarf design 1989
Film: "Boomalli, 5 Koorie Artists", directed by Michael Riley, Film Australia, 1988

EUPHEMIA BOSTOCK

Born: 1936, Tweed Heads
Studies: Sculpture, East Sydney Technical College, Textile Design, Sydney College of the Arts (now The Design Faculty, Institute of Technology, Sydney), EORA Centre
Grants: Aboriginal Arts Board Grant, 1986; Aboriginal Medical Service Sydney for Paris Fashion parade, 1987
Exhibitions: Group: NSW Aboriginal Women's Art Exhibition, Government Information Office, Sydney, 1982; "Koori Art '84", Artspace, Sydney, 1984; EORA, 1984; Aboriginal Fashion Parade, Sydney, 1985; "Anytown" Fashion Event, Melbourne, 1985; Aboriginal Fashion Parade, Sydney, 1986; "Urban Koories", Willoughby Workshop Arts Centre, Sydney, 1986; "Women's Art Exhibition", Sydney, 1987, Aboriginal Fashion Parade, Paris, France, Sydney, Canberra; "Boomalli Au Go Go", Boomalli Aboriginal Artists Ko-operative Gallery, Sydney, 1987; "De Facto Apartheid", Boomalli Aboriginal Artists Ko-operative Exhibition, Performance Space, Sydney; 1988; Eurobla Exhibition, Tin Sheds Gallery, Sydney 1988; "ANCAA and Boomalli", Boomalli Aboriginal Artists Ko-operative Gallery, Sydney, 1988
Represented: Australian National Gallery, Canberra

ROBERT CAMPBELL JNR

Born: 1944, Kempsey

Exhibitions: Solo: Roslyn Oxley9 Gallery, Sydney, 1989; Christine Abrahams Gallery, Melbourne, 1989

Group: Roslyn Oxley9 Gallery, Sydney, 1987; "Aboriginal Australian Views in Print and Poster", Australian Print Council, Melbourne, 1987; UK, 1988; Lismore Regional Gallery, 1987; "Other Landscapes", United Artists Gallery, Melbourne, 1988; Roslyn Oxley9 Gallery, Sydney, 1988, "The Cocktail Party", Roslyn Oxley9 Gallery, 1988; Exhibited in The Wynne Prize, Art Gallery of New South Wales, 1988; Self Portrait Show, David Jones Art Gallery, Sydney, 1988; "Recent Aboriginal Painting", Art Gallery of South Australia, 1988; "A Changing Relationship: Aboriginal Themes in Australian Art, 1938–1988", S. H. Ervin Gallery, Sydney, 1988; "Prints and Australia: Pre-Settlement to Present", Australian National Gallery, Canberra, 1989

Represented: Australian National Gallery, Canberra; Artbank; Regional Galleries Association of Queensland; Sir William Dobell Art Foundation; Robert Holmes à Court Collection; Art Gallery of Western Australia; Art Gallery of South Australia

Commissions: Australian Bicentennial Authority, Poster Commission; front cover, *Art in Australia*

Appointments: Artist-in-Residence, Tin Sheds, University of Sydney; participated in "Second Regional Consultation on People's Culture" (incorporating the Asian Cultural Forum on Development) Manila, 1988

MABEL EDMUND AM

Born: 1930, Rockhampton

Studies: Associate Diploma of Art (Aborigine and Torrest Strait Islander), TAFE, Cairns, 1986

Exhibitions: Solo: Rockhampton Art Gallery, 1987, 1988; The Hill Gallery, Yeppoon

Group: Raintrees Art Gallery, Cairns, 1985; Dabbles on Days Gallery, Brisbane, 1986 (with Jenuarrie); Pacific International Hotel Cairns, 1986; Queensland Museum, Brisbane, 1988; Jindah Art Gallery, Gayndah, 1988; TAFE Aboriginal and Islander Vocational Arts and Craft, Ben Grady Gallery, Canberra, 1986

Honours: Order of Australia, 1986

Represented: Holmes à Court Collection; Australian National Gallery, Canberra; Queensland Museum

FIONA FOLEY

Born: 1964, Maryborough

Studies: East Sydney Technical College, Certificate of Art, 1983; Sydney College of the Arts, Bachelor of Visual Arts, 1986; Sydney Institute of Education, Sydney University, Diploma of Education, 1987

Grants: Special Study Grant — field trip to Bathurst Island and Ramingining 1985; Aboriginal Arts Board Grant — field trip to Ramingining 1986; Aboriginal Arts Board, Professional Development Grant, 1988

Exhibitions: Solo: Roslyn Oxley9 Gallery, Sydney, 1988

Group: "Koori Art '84", Artspace, Sydney, 1984; Butchers Exhibit Gallery, 1984; Aboriginal Artists Gallery, Melbourne and Sydney, 1985; "Urban Koories", Willoughby Workshop Arts Centre, Sydney, 1986; "Art Bites", Piers 2 and 3, Walsh Bay, Sydney, 1986; "Aboriginal Australian Views in Print and Poster", Australian Print Council, Melbourne, 1987; "Boomalli Au Go Go", Boomalli Aboriginal Artists Ko-operative Gallery, Sydney, 1987; "From Pukumani Poles to Sand Paintings", Craft Centre Gallery, Sydney, 1988; "De Facto Apartheid", Boomalli Exhibition, Performance Space, Sydney, 1988; "Urban Aboriginal Art: A Selective View", Contemporary Art Centre of South Australia, 1988; "ANCAA and Boomalli", Boomalli Aboriginal Artists Ko-operative Gallery, Sydney, 1988; "The Cocktail Party", Roslyn Oxley9 Gallery, Sydney, 1988

Represented: Australian National Gallery, Canberra; Australian National Museum, Canberra; Flinders University Art Museum; Artbank; Art Gallery of New South Wales; Art Gallery of South Australia

Appointments: Artist-in-Residence, Griffith University, 1988

Commissions: South Sydney Project Mural, Cleveland Street High School, 1985; Sydney University Settlement Mural 1985 and 1987; Survival Poster, Aboriginal Island Dance Theatre 1987; Survival Poster Project, Northern Land Council, 1988; *Land Right News* cover design

Film: "Boomalli, 5 Koori Artists", directed by Michael Riley, Film Australia, 1988

LESLIE GRIGGS

Born: 1958, Melbourne
Grants: Aboriginal Arts Board Grant, 1988
Exhibitions: "Contemporary Koori Artists", Doncaster Art Gallery, Melbourne; 5th Festival of Pacific Arts, Townsville, 1988; "Artists and Architects", Meat Market Craft Centre; "Recent Art", South Australian Art Gallery
Represented: Art Gallery of South Australia; Victorian Aboriginal Cultural Heritage Trust
Appointments: Australian Delegate at 5th Festival of Pacific Arts Townsville

JENUARRIE JUDITH WARRIE

Born: 1944, Rockhampton
Studies: Associate Diploma of Art (Aborigine and Torres Strait Islander), TAFE, Cairns, 1985
Awards: Andrew and Lillian Pedersen Memorial Prize for Printmaking and Drawing, Queensland Art Gallery, 1987
Grants: Establishment Grant, Aboriginal Arts Board Cultural Exchange to New Zealand, 1988
Exhibitions: Solo: Dabbles on Days Gallery, Brisbane, 1986
Group: "Down to Earth" Potters Exhibition, Cairns Museum, Cairns, 1985; TAFE Aboriginal and Islander Arts and Craft, Raintrees Gallery, Cairns, 1985; TAFE Aboriginal and Islander Vocational Arts and Craft, Ben Grady Gallery, Canberra, 1986; "Dalkuna Mnunuway Nhe Rom", Foreign Exchange International Exhibition Centre, Armadale, Melbourne, 1987; "Aboriginal Australian Views in Print and Poster", Australian Print Council, Melbourne, 1987; Arts Council of Australia, Sydney, 1987; Ageless Art, Queensland Museum, Brisbane, 1988; National Women's Art Award, Southport, 1988
Represented: Australian National Gallery, Canberra; Queensland Art Gallery; Victorian Art Gallery; Robert Holmes à Court Collection; French Embassy; National Trust; Adelaide Museum; Queensland Museum
Residencies: Capricornia Potters Club; Guest Artist, St Josephs College, Brisbane, 1987

PAMELA JOHNSTON

Born: Sydney
Studies: Art Certificate, East Sydney Technical College, 1987; Higher Certificate in Fine Art, National Art School, 1988; Master of Arts, City Art Institute,1989
Awards: Lucien Mochalski Bequest, 1987
Grants: Arts Council Grant 1982, 1984
Exhibitions: Solo: Kelly Street Kolektiv Gallery, Sydney, 1987: "One Land — One People — One Law", Balmain Loft Gallery, Sydney, 1988; Kelly Street Kolektiv, Sydney,1988; Boomalli Aboriginal Artists Ko-operative Gallery, 1988; Works Gallery, City Art Institute, 1988, 1989
Group: Exhibitions at Cell Block Theatre, Sydney, 1986; "Cool, Calm and Kolektiv", Kelly Street Kolektiv Gallery, Sydney, 1986; "Women's War and Peace Exhibition", Sydney, 1987; "Spiritus Kolektivi", Artzone Gallery, Adelaide, 1987; Exhibitions at Cell Block Theatre, Sydney, 1987; Sydney University Members Club, Sydney, 1987; "Imprison", Kelly Street Kolektiv Gallery, Sydney, 1988; "Women's Art Show", Bondi Pavilion, Sydney, 1988; Women's Show Redfern, 1988; Sydney University Members Club, Sydney, 1988; "Unearthing the Goddess", Kelly Street Kolektiv Gallery, Sydney, 1988; Women's Show, Cell Block, Sydney, 1988, "ANCAA and Boomalli", Boomalli Aboriginal Artists Ko-operative Gallery, Sydney, 1988

ELLEN JOSÉ

Born: 1951, Cairns
Studies: Certificate in Applied Art, Seven Hills Art College, Brisbane, 1976; Diploma in Fine Art, Preston Institute of Technology, Melbourne, 1978; Diploma in Education, Melbourne State College, Melbourne, 1979
Award: 1st Prize Williamstown Art Festival, 1989
Exhibitions: Solo: Aboriginal Artists Gallery, Melbourne 1987 (with assistance of a grant by Aboriginal Arts Board of the Australia Council)
Group: National Aboriginal Award Exhibition, Northern Territory Museum and Art Gallery, Darwin, 1985, 1986, 1987; Aboriginal Artists Gallery, Melbourne, 1986; NADOC '86 Exhibition of Aboriginal and Islander Photographers, Aboriginal Artists Gallery, Sydney and Melbourne 1986; "Aboriginal Australian Views in Print and Poster", Australian Print Council, Melbourne, 1987, UK, 1988; Bendigo High School, Bendigo, 1988; "Inside Black Australia", Albert Hall, Canberra, Tin Sheds, Sydney, and London, 1988–89; Addendum Gallery 1, Fremantle, 1988; "Prints and Australia: Pre-Settlement to Present", Australian National Gallery, Canberra, 1989
Represented: Women's Art Register, Melbourne; National Gallery of Victoria; Australian National Gallery, Canberra; Holmes à Court Collection; Dr Les Ferbve Collection; Tasmanian National Museum Gallery; NSW State Library
Commissions: "Painting Fridge Doors", Philips Industries, Sydney and Melbourne, 1987 (with Jenny Kee, Ken Done and Michael Leunig); "4 Prints", Australian National Gallery, Canberra, 1988, India, 1989; "100 x 100 Folio", Australian Print Council, Melbourne, 1988; "Patron Print", Australian Print Council, Melbourne, 1988

JOSEPH MCIVOR

Born: 1969, Cooktown
Studies: Currently undertaking an Associate Diploma of Art (Aborigine and Torres Strait Islander) TAFE, Cairns
Exhibitions: Group: Pacific International Hotel, 1987, 1988; "Ageless Art Exhibition", Queensland Museum, Brisbane, 1988; Arts Centre, Cairns, 1988
Represented: Canberra College of Advanced Education Collection; Private Collections

BANDUK MARIKA

Born: 1954, Yirrkala
Grants: Aboriginal Arts Board, Artist Fellowship, 1985, 1986, 1987
Exhibitions: Solo: Old Meadows Gallery, Blacktown, NSW, 1983; Rex Irwin Gallery, Sydney, 1985; Alliance Francaise, Sydney, 1987; Alliance Francaise, Canberra, 1987
Group: Seasons Gallery, North Sydney, Women's Festival, 1982; Up Cake Gallery, Fairfield, 1983; The Blacktown Exhibition Shopping Centre Display, 1983; "Miyalko" Aboriginal Women's Art, Seasons Gallery, North Sydney, 1983; "Koori Art '84", Artspace, Sydney, 1984; Araluen Centre, Alice Springs, 1984; "Miyalko" Aboriginal Women's Art, Seasons Gallery, North Sydney, 1984; "Urban Koories", Willoughby Workshop Arts Centre, Sydney, 1986; "Miyalko" Aboriginal Women's Art, Seasons Gallery, North Sydney, 1986; "The Marika Sisters", Australian Museum, Sydney, 1987; Art & Aboriginality, Aspex Gallery, Portsmouth, England, 1987; "Encounters" South Australian School of Art, 1988
Represented: Australian National Gallery; Ministry of Aboriginal Affairs; Flinders University Art Museum; Australian National University; Artbank; State Bank; The Australian Museum; South Australian Museum; Museums and Art Galleries of the Northern Territory; Queensland Museum
Appointments: Artist-in-Residence, Canberra School of Art, 1984; Artist-in-Residence, Flinders University, 1986; leader of cultural delegation to Papua New Guinea for Aboriginal Arts Festival, sponsored by Department of Foreign Affairs; film consultant; translator for Channel 0 and Film Australia
Commissions: Mural, Pier 1; Special Commission for Australian National Gallery, 1986; terrazzo floor design, Harbourside Marketplace, Sydney, 1987; limited edition print for Australian National Gallery, 1988; design for Bicentennial Touring Exhibition, 1988

FERNANDA MARTINS

Born: 1955, Sydney

Studies: BA Fine Art, Torrens College of Advanced Education, SA, 1979; Art Studies, East Sydney Technical College 1982–85; Graduate Diploma in Art Education (secondary), Sydney College of Advanced Education, 1987

Grants: Visual Arts Board Regional Development Program, 1980

Exhibitions: Solo: "Up the Pub", Experimental Art Foundation, SA, 1975

Group: "The Women's Show Adelaide", SA School of Art, 1977; "The Union Show", Women's Art Movement (WAM), Adelaide University, 1979; "Free Fall Through Featherless Flight", WAM, SA, 1979; "Performance of Documentation 1", Botanical Gardens, SA, 1979; "Performance of Documentation 2", Experimental Art Foundation, SA, 1979; "Spring Video Show", Box Factory, SA, 1979; "Graduation Exhibition", Contemporary Art Society, SA, 1979; "17 Viewpoints", Flight Gallery, SA, 1980; "Sleep Has Its House", WAM, 1980; "From The Bottom To The Top", Adelaide Festival of Arts, 1982, (toured to Regional Galleries in SA and NT); "Photography at Art Unit", Sydney, 1982; "Women and the Arts Festival", Craft Council, Sydney, 1982; Art Unit Group Exhibitions, Sydney, 1984; "Koori Art '84", Artspace, Sydney, 1984, "Cumberland CAE", Sydney, 1986; "Exiles or Expatriates", Adelaide Festival Theatre, 1986; "Boomalli Au Go Go", Boomalli Aboriginal Artists Ko-operative Gallery, Sydney, 1987; Craft Council of NSW Permanent Exhibition, The Rocks, Sydney, 1985 and 1986; "ANCAA & Boomalli", Boomalli Aboriginal Artists Ko-operative Gallery, Sydney, 1988; "Eurobla Show", Tin Sheds, Sydney, 1988

Appointments: Assistant to printmaker, Charles Bannon, 1976; Artist-in-Residence, All Saints College, Bathurst, 1983; Assistant to sculptor Bert Flugelman, 1983; Art teaching at Tranby Aboriginal Co-operative College, Sydney, 1985–87; Education Officer for Art Gallery of NSW

Commissions: Murals for Circus Oz rehearsal space and tent, Adelaide 1975; designs and illustrations for publications including NSW Education Dossier, Sydney, front cover, 1987, and Independent Aboriginal Controlled Education Institutions Journal 1, 1987; program and poster designs including Shorkel Band, Sydney, 1983–84; Koomparto Festival, Bondi Pavilion, 1988; Australian Film Institute's "Time on Screen"; Northern and Central Land Councils' Trick or Treaty Poster; "Whispers in the Heart", Side Track Theatre Company

RAYMOND MEEKS ARONE

Born: 1957, Sydney

Studies: Certificate of Art, Queensland Institute of Technology, 1975; Certificate of Art, Kogarah College of Art, 1977; Diploma in Art, Alexander Mackie College of Advanced Education, 1980; Bachelor of Arts (Visual Arts) City Art Institute

Awards: Crichton Award for Children's Book Illustration; Aboriginal National Theatre Trust Award of Excellence in Visual Arts, 1988

Exhibitions: German Exhibitions — Munich, Dusseldorf and Kline, 1978; Bauxhau Stone Gallery, 1979; Seymour Centre, Sydney, 1980; Rotary Clubs, Ampira Shows, Paddington Town Hall, Sydney, 1981; Aboriginal Week, Art Gallery of New South Wales, 1982; Contemporary Aboriginal Art Exhibition, Bondi Community Pavilion, Sydney, 1983; "Koori Art '84", Artspace, Sydney, 1984; "Urban Koories", Willoughby Workshop Arts Centre, Sydney, 1986; Cooper Gallery, Sydney, 1987; Foreign Exchange Gallery, Melbourne, 1987; Art & Aboriginality, Aspex Gallery, Portsmouth, England, 1987; Aboriginal Print and Poster Exhibition, Canberra, 1987; Coo-ee Australian Emporium, Sydney, 1987; Australian Geographics, 1987; Craft Council Exhibition, Sydney, 1988; Aboriginal Artists Gallery, 1988; Perc Tucker Gallery, Townsville, 1988; Aboriginal Print Exhibition, 1988; Capricorn Galleries, Port Douglas, 1988; "ANCAA and Boomalli", Boomalli Aboriginal Artists Ko-operative Gallery, Sydney 1988

Represented: Australian Museum, Sydney; Australian National Gallery, Canberra; Aboriginal Artists Gallery, Sydney; Australia Post; National Gallery, Japan; Holmes à Court Collection; Art Gallery of New South Wales; Art Gallery of Western Australia

Appointments: Artist-in-Residence, Canberra School of Art, 1985; Design Consultant, 5th Festival of Pacific Arts, Townsville, 1988; Artist-in-Residence, Canberra School of Art, 1988; Artist-in-Residence, Cairns, TAFE, 1988

Commissions: Bondi Beach Mosaic Mural; Australia Day stamp, 1986 Australia Post; poster design for *Honeyspot* by Jack Davis, Australian Elizabethan Theatre Trust; poster designs for Coo-ee Emporium, and "Koori Art '84"; book illustrations for publications including *Central Arnhem Land Stories for Children, Black Man Coming* by Gerry Bostock; *White Kit* — Tiwi children's book; Gold Coast Centre Gallery mural (working with David Malangi); Mural for Department of Aboriginal Affairs

Film: "Boomalli, 5 Koorie Artists", directed by Michael Riley, Film Australia, 1988

SALLY MORGAN

Born: 1951, Perth
Exhibitions: Group: Blaxland Gallery, Sydney, 1987; "Aboriginal Views in Poster and Print", Australian Print Council, Melbourne, 1987; "Art and Aboriginality", Aspex Gallery, Portsmouth, UK, 1987; Contemporary Aboriginal Art, Birukmarri Gallery, Perth, 1987; Aboriginal Printmakers, Addendum Gallery, Fremantle, 1988; "Right Here Right Now", Adelaide, 1988; Aboriginal Printmakers, Tynte Gallery, Adelaide, 1988; Arrhaus Festival, Denmark, 1988; **Solo:** Birukmarri Gallery, Perth, 1989; Hogarth Gallery, Sydney, 1989
Represented: Christensen Fund; Sir William Dobell Art Foundation; Australian National Gallery, Canberra; Holmes à Court Collection
Commissions: Festival of Perth Design, 1989; Australian Government Touring Exhibition, 1988

MUNDABAREE JENNIFER GREEN

Born: 1952, Mareeba
Studies: Associate Diploma of Art (Aborigine and Torres Strait Islander) TAFE, Cairns
Awards: Grafton House Award for Best Painting by an Aboriginal Artist in the 1988 Cairns Art Society 42nd Annual Exhibition
Exhibitions: Group: Pacific International Hotel, Cairns 1987–88; "Ageless Art", Queensland Museum, Brisbane, 1988; Festival of Pacific Arts, Townsville, 1988; Cairns Art Society 42nd Annual Art Exhibition, Cairns, 1988
Represented: Australian Collection, Australian National Gallery, Canberra; Private Collections including Queen of Spain
Commissions: Painted simulated rock art shelter in Stockman's Hall of Fame, Longreach, 1988

TREVOR NICKOLLS

Born: 1949, Adelaide

Studies: Diploma in Fine Art Painting, South Australian School of Art, 1970; Western Teachers' College, South Australian College of Advanced Education, 1972; Canberra College of Advanced Education, 1977; Diploma in Teaching, SA College of Advanced Education, 1978; Post Graduate Diploma in Painting, Victorian College of Arts, 1980

Awards: Canberra Civic Permanent Art Award, 1976; Alice Springs Acquisition Art Award, 1980; Jacaranda Art Society Acquisitive Drawing Prize, Grafton, 1988

Grants: Art Grant, Visual Arts Board, Australia Council; Aboriginal Arts Board Grant, Australia Council; Creative Arts Fellowship, Australian National University

Exhibitions: Solo: "From Dreamtime to Machinetime", Canberra Theatre Centre Gallery, 1978; The Arts Centre, Australian National University, Canberra, 1980; The Bitumen River Gallery, Canberra, 1981; The Aboriginal Artists Gallery, Sydney, 1981; The Hogarth Gallery, Sydney, 1981; The Museum and Art Galleries of the Northern Territory, Darwin, 1982; Piaf Gallery, Melbourne, 1984; Union Street Gallery, Sydney, 1985; Holdsworth Contemporary, Sydney, 1986; Solander Gallery, Canberra, 1987; Holdsworth Contemporary, Sydney, 1987; Mini MOCKA Museum of Contemporary Art, Brisbane, 1988

Group: 1971 "The Three Young Artists", Lombard Gallery, Adelaide, 1971; The Lewellyn Gallery; The Contemporary Arts Centre, The Royal Arts Society, Adelaide, 1972–75; Realities Gallery, Melbourne, 1980; Morwell Aboriginal Art Gallery, 1982; "Ex-patriots", Contemporary Art Centre, Adelaide, 1984; "The Dreamtime Today", Royal South Australian Society of Arts, 1986; The Aboriginal Art Gallery, Adelaide, 1986; "Dreamtime/Machinetime", at Iwalewa Haus, Bayreuth, West Germany, 1987; "Art and Aboriginality", Aspex Gallery, Portsmouth, England, 1987; Sydney Opera House, 1987; "Aboriginal Themes in Australian Art, c1938–1988", National Trust Centre, Sydney, 1987; "The New Generation, 1983–88", The Phillip Morris Arts Grant Purchases, Australian National Gallery, Canberra, 1988; "Urban Aboriginal Art: A Selective View", Contemporary Arts Centre of South Australia, 1988; "Australian Art, Post 1960", Deutscher, Gertrude Street, Melbourne, 1988; 1st Australian Contemporary Art Fair, Melbourne, 1988; Nevada, USA, 1988; Jacaranda Art Society, Acquisitive Drawing Prize, Grafton Aboriginal Gallery, NSW, 1988; "Recent Aboriginal Painting", The Art Gallery of South Australia, 1988; "Introduction to Aboriginal Art", Moree Plains Gallery, NSW, 1988

Collections: Australian National Gallery, Canberra; National Gallery of Victoria; Art Gallery of South Australia; The Art Gallery of Western Australia; Northern Territory Museum of Arts and Sciences; The Australian National University, Canberra; Flinders University, South Australia; James Cook University, Townsville, Queensland; Canberra College of Advanced Education; Melbourne College of Advanced Education; NSW Institute of Technology, Sydney; Australian Bicentennial Authority; The Department of Aboriginal Affairs; Iwalewa Haus, Bayreuth, West Germany; Phillip Morris Collection

Commissions: Department of the Prime Minister and Cabinet, gift for visiting VIP; Australian Bicentennial Authority, mural; NSW Institute of Technology, Sydney, painting; Victorian Ministry for the Arts, to paint a tram; Australia Square, Sydney, outdoor mural; Civic Permanent Square, Melbourne, outdoor mural; painting of Pru Acton costume design for the Australian entrant in "Miss Universe" pagent, 1984; Department of Aboriginal Affairs, Canberra, painting; illustrations for *Black Man Coming*, poetry book by Gerald Bostock; illustrations for limited edition poetry broadsheets, Australian National University Press; book illustrations for Department of Aboriginal Affairs, Canberra; poster designs for Aboriginal Theatre, Sydney; cover design for Pivot, SA Department of Education publication; logo for "Aboriginal Arts and Crafts", Melbourne

Film: "Dreamtime Machinetime", produced by Don Featherstone, ABC TV

Lin Onus GANADILA NUMBER 2

Born: 1948, Melbourne
Awards: The Museums and Art Galleries Award, 1988; National Aboriginal Art Award, Darwin, 1988
Exhibitions: Solo: Aborigines Advancement League, Melbourne, 1975; Taurinus Gallery, Melbourne, 1976; Holdsworth Gallery, Sydney, 1977; Hesley Galleries, Canberra, 1978; Gallery 333, Melbourne, 1979; Auburn Galleries, Melbourne, 1982; Koori Kollij, Melbourne; Gallery Gabrielle Pizzi, Melbourne, 1988
Group: "Musqito Series" — in conjunction with "Koori Art '84", Art Gallery of New South Wales, 1984; Morwell Regional Gallery, 1985; "Dalkuna Mnunuway Nhe Rom" Seven Maori Artists — Seven Aboriginal Artists, Foreign Exchange, Melbourne, 1987; "Art and Aboriginality", Aspex Gallery, Portsmouth, England, 1987; S. H. Ervin Gallery, Sydney, 1988; "Koori Art" Doncaster Gallery (in conjunction with Victorian Aboriginal Culture Heritage Trust), 1988; "Bulawirri/Bugaja", National Gallery of Victoria, 1988; "Urban Aboriginal Art: A Selective View", Contemporary Arts Centre of South Australia, 1988
Represented: Aboriginal Advancement League — "Musqito Series", State Museum of Victoria; Flinders University, SA; Art Gallery of Western Australia; Art Gallery of the Northern Territory; Australian National Gallery, Canberra; Holmes à Court Collection; Art Gallery of South Australia
Appointments: "Artist in the Community" for Victorian Ministry for the Arts, 1982; Victorian Representative to the Aboriginal Arts Board of the Australia Council, 1986

Jimmy Pike

Born: 1940, Great Sandy Desert
Exhibitions: Solo: Aboriginal Artists Gallery, Melbourne, 1985; Aboriginal Artists Gallery, Sydney, 1986; Black Swan Gallery, Fremantle, 1986; Tynte Gallery, Adelaide, 1987; Craft Centre Gallery, Sydney, 1987; Seibu Shibuya, Tokyo, 1987; Australian Consulate, Hong Kong, 1987; Birukmarri Gallery, Fremantle, 1988; Capricorn Gallery, Port Douglas, 1988; Tynte Gallery, Adelaide, 1988; Blaxland Gallery, Sydney and Melbourne, 1988
Group: Including Her Majesty's Theatre, Perth, 1984; Praxis Gallery, Fremantle, 1985; Print Council Gallery, Melbourne, 1987; Galerie Exler, Frankfurt, 1987; Addendum Gallery, Fremantle, 1988, Blaxland Galleries, Sydney, 1988
Commissions: BHP, Mt Newman Mining, 1987; Bicentennial poster, 1988
Represented: Australian National Gallery, Canberra; Art Gallery of Western Australia; National Gallery of Victoria; Art Gallery of South Australia; Art Gallery of New South Wales; Christensen Fund; Australian Museum

POOARAAR BEVAN HAYWARD

Born: 1939, Gnowangerup

Studies: Associate Diploma of Art (Aborigine and Torres Strait Islander Art), TAFE, Cairns, 1987; Canberra School of Art, Canberra 1988–

Exhibitions: Group: Ben Grady Gallery, Kingston, ACT 1986; Pacific Hotel, Cairns 1986–87; ''Ageless Art'', Queensland Museum, Brisbane 1988; Touring Aboriginal Prints Exhibition, Australian Print Council, 1987–88 (toured Australia, Britain and India); International Independent Exhibition of Prints in Kanagawa, Yodahama, 1988; International Centre of Graphic Arts, MGLC Mednarochni Grappicru Likovni Center, Yugoslavia, 1989

Represented: Australian National Gallery, Canberra; Heytesbury Holdings Collection, Perth

AVRIL QUAILL

Born: 1958, Brisbane

Studies: Bachelor of Arts (Visual Arts), Sydney College of the Arts, 1985

Grants: Aboriginal Arts Board, Professional Development Grant, 1986

Exhibitions: Rotary Clubs, Ampira Shows, Paddington Town Hall, Sydney, 1981; Experimental Art Foundation, Adelaide, 1984; ''Koori Art '84'', Artspace, Sydney, 1984; ''The Aboriginal Art Exhibition'', Sydney University Settlement, Sydney, 1985; ''Boomalli Au Go Go'', Boomalli Aboriginal Artists Ko-operative Gallery, Sydney, 1987; ''De Facto Apartheid'', Boomalli Exhibition, Performance Space, Sydney, 1988; ''Eurobla'', Tin Sheds Gallery, Sydney University, 1988; ''ANCAA and Boomalli'', Boomalli Aboriginal Artists Ko-operative Gallery, Sydney, 1988

Represented: Australian National Gallery, Canberra; University of Sydney; Flinders University

Commissions: ''Traditional Mural Project'', Central Railway Station, Sydney for Carnivale 1984; M. J. Hayes Mural Project, Newtown; banner for Committee to Defend Black Rights; mural at Cleveland Street High School, Alexandria; illustrations, design and production of publications and posters including program for Tranby Aboriginal College, Sydney, QANTAS poster, paintings for Aboriginal Cricket Association, booklets and poster for Aboriginal Medical Service; artist's assistant on public murals; Gold Coast Centre Gallery mural (working with David Malangi)

JEFFREY SAMUELS

Born: 1956, Bourke
Studies: National Art School, Sydney, 1974; Diploma in Art, Alexander Mackie College of Advanced Education, Sydney, 1978; Bachelor of Arts (Visual), City Art Institute, Sydney, 1984
Exhibitions: Group: Aboriginal Arts and Crafts, Sydney, 1978; East End Art Gallery, Sydney, 1979; Cologne, Germany, 1979; Nuremburg, Germany, 1979; Dusseldorf, Germany, 1979; Frankfurt, Germany, 1979–80; Munich, Germany, 1979–81; East End Art Gallery, Sydney, 1980; Cultural Centre, Sydney, 1980–81; Jolly Barry Gallery, Sydney, 1980; "Artists for Aboriginal Land Rights", Ampira Festival Committee, Sydney, 1981–82; Global Cultural Centre, Sydney, 1982; Mosman Art Prize, Sydney, 1983; "National Aboriginal Week", Australian Museum, Sydney 1983–84; Randwick Art Exhibition, Sydney, 1983–84; "The Blake Prize for Religious Art", Commonwealth Bank, Sydney, 1983–84; Exhibition of Contemporary Aboriginal Art, Bondi Pavilion, Sydney, 1983–84; Cowra Aboriginal Festival, Cowra, 1984; "Koori Art '84", Artspace, Sydney, 1984; "Artists for Peace", Rod Shaw Studio, Sydney, 1984; Collectors Gallery of Aboriginal Art, Sydney, 1984; National Aboriginal Art Competition, Darwin, 1984; Aboriginal Artists' Gallery, Melbourne, 1984; "National Aboriginal Week", NSW Art Gallery, Sydney, 1985; "A Contemporary Survey", Canberra National Art School, Canberra, 1985; "A Contemporary Survey", Blaxland Gallery, Sydney, 1986; "Te Ao Marama — Dalkuna Mnunuwuy Nhe Rom", Exhibition of Contemporary Aboriginal and Maori Art, Melbourne, 1987; "Boomalli Au Go Go", Boomalli Aboriginal Artists Ko-operative, Sydney, 1987; "Aboriginal Australian Views in Print and Poster", Australian Print Council, 1987–88 (Curated by Jeffrey Samuels and Chris Watson); "Bicentennial Blue", Temeraire Gallery, Narellan, 1988; "De Facto Apartheid", The Performance Space, Sydney, 1988; "Eurobla", The Tin Sheds Gallery, Sydney, 1988
Commissions/Collections: Aborigines Woomera, Sydney, 1976; Aboriginal and Islander Dance Theatre, Sydney, 1978; Aboriginal Arts Board, Sydney, 1979; Paul Hamlyn Pty Ltd, Sydney, 1979; Department of Immigration and Ethnic Affairs, Canberra, 1979; Ampira Festival Committee, Sydney, 1981; Aboriginal and Islander Dance Theatre, Sydney, 1981; Aboriginal Arts Board, Sydney, 1982; Aborigines Woomera, Sydney, 1982–83; Toe Truck Theatre Company, Sydney, 1983–84; Teachers Federation of NSW, Sydney, 1985–86; Art Gallery of New South Wales, Sydney, 1985–86

ZANE SAUNDERS

Born: 1971, Cairns
Studies: Currently undertaking an Associate Diploma of Art (Aborigine and Torres Strait Islander), TAFE, Cairns
Awards: Cairns City Council Purchase Award, 1988; Cairns City Bicentennial Community Committee Art Scholarship; Grafton House Galleries Award
Exhibitions: Pacific International Hotel, Cairns, 1987; "Ageless Art", Queensland Museum, Brisbane, 1988; South Pacific Festival of Art, Townsville, 1988; Cairns Art Society 42nd Annual Art Exhibition, 1988
Represented: Queensland Art Gallery, Brisbane; Cairns Regional Collection, Cairns; James Cook University Fibre Art Collections, Townsville; "Rock Painting" Stockman's Hall of Fame, Longreach, 1988

BARNEY DANIELS TJUNGURRAYI

Born: c.1949, Haasts Bluff
Exhibitions: Group: Gauguin Museum, Tahiti, 1987; Bicentennial Exhibition, 1988;
continuous showing Centre for Aboriginal Artists, Alice Springs
Represented: State Art Galleries; Holmes à Court Collection; Malcolm Forbes Collection,
New York; Flinders University Art Museum
Commission: Australian Bicentennial Authority for the Australian Bicentennial Exhibition,
painted television and furniture

HEATHER WALKER

Born: 1942, Rockhampton
Studies: Associate Diploma of Art (Aborigine and Torrest Strait Islander), TAFE, Cairns, 1986
Awards: National Aboriginal Art Award, 1988
Exhibitions: Aboriginal and Islander Arts and Craft, Cairns, 1987; Tynte Gallery, Adelaide,
1988; Aboriginal Arts Australia, Sydney, 1988; Nakina Fine Arts, Brisbane, 1988;
Queensland Museum, Brisbane, 1988; National Women's Art Award, Southport, 1988
Represented: Australian National Gallery, Canberra; Museums and Art Galleries of the
Northern Territory; Cultural Service, French Embassy, Canberra

WANJIDARI LEANNE REID

Born: 1965, Rockhampton
Studies: Associate Diploma of Art (Aborigine and Torrest Strait Islander), TAFE, Cairns, 1986
Exhibitions: Solo: Gabrielle Pizzi Gallery, Melbourne, 1988
Group: Art Centre Students, Cairns and Canberra; Memorial Exhibition for Dick Roughesy,
Upstairs Gallery, Cairns; TAFE Aboriginal and Islander Vocational Arts and Craft, Ben Grady
Gallery, Canberra, 1986; Blaxland Gallery, Sydney; Gould Gallery, Melbourne; Burwill
Gallery, Brisbane; Visions Gallery, Surfers Paradise; "Ageless Art", Queensland Museum,
Brisbane, 1988
Represented: Queensland Art Gallery; Holmes à Court Collection; BHP Collection; French
Embassy, Canberra

LIST OF PLATES